IMAGES
of America

MT. RUSHMORE
AND KEYSTONE

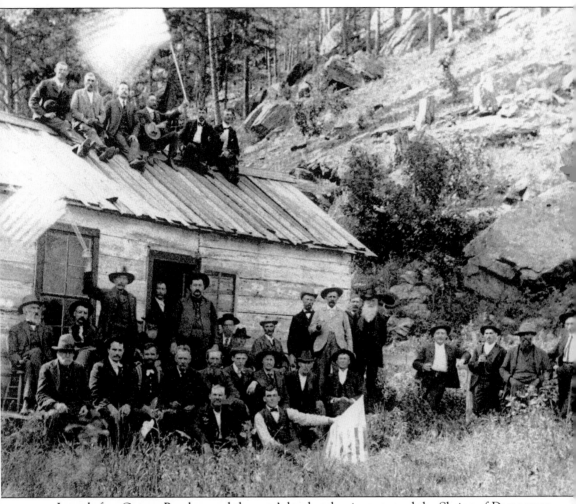

Long before Gutzon Borglum and the area's hard rock miners carved the Shrine of Democracy on Mount Rushmore, patriotism was fervently celebrated in Keystone. In this photograph, area miners pose on July 4, 1894, at the Holy Terror Mine. On June 28 of that year, William Franklin and his adopted daughter, Cora Stone, were hiking along the base of Mount Aetna. Stone picked up a chip of quartz loaded with gold, thereby locating the richest lode claim in the southern Black Hills. Without delay, Franklin walked the 20 rugged miles to Rapid City to file on his new claim. He was so jubilant that he partied for several days in the city. Upon his return to Keystone, he was met with the fury of his wife, Jennie. William soothed her temper, telling her, "I named the mine after you, my dear, sweet wife." Several days later, she learned he had named the claim the "Holy Terror." On July 4, William invited all the miners in the Black Hills to a celebration, telling them they could pick up any specimens they wished on his and Cora Stone's find. Some of the specimens the miners gathered can still be found in private collections today. (Photograph courtesy of Howard "Howdy" Peterson.)

On the cover: Drilling and blasting came naturally to local Keystone hard rock miners, who are working on the bust of George Washington in this photograph taken during the early carving years. They welcomed their jobs during the Depression years, although the miners did not appreciate the great work they were accomplishing until many years after the completion of the sculpture. (Photograph courtesy of the Keystone Historical Museum.)

IMAGES
of America

MT. RUSHMORE
AND KEYSTONE

Tom Domek and Robert E. Hayes

ARCADIA
PUBLISHING

Published by Arcadia Publishing
Charleston, South Carolina

Printed in the United States of America

Library of Congress Catalog Card Number: 2005936486

For all general information contact Arcadia Publishing at:
Telephone 843-853-2070
Fax 843-853-0044
E-mail sales@arcadiapublishing.com
For customer service and orders:
Toll-Free 1-888-313-2665

Visit us on the Internet at www.arcadiapublishing.com

This book is dedicated to the many Rushmore workers—including Robert Hayes's father, Edwald—and their families who spent the better part of 14 years assisting Gutzon Borglum during the carving of Mount Rushmore; also, to Rex Allen Smith, an important Rushmore historian without whom so much history would have been lost.

CONTENTS

ACKNOWLEDGMENTS

The authors are grateful for those who loaned photographs from their collections, including the Keystone Area Historical Society. Thanks to the early studios and photographers, including Rise Photo, Bell Studios, Alice Ozmun, Carl Loocke, and O. A. Vik Studios. Many early Mount Rushmore photographs came from the archives of the National Park Service as well as private collections, including the Jay Shepard family, Lorraine Judson Griffin, and Edith Bruner Nettleton. Other early photographs came from James and Lois Halley, Doug Hesnard, Stella Hughes, Helen Wrede, and Reid Riner of Minnilusa Pioneer Association. Other contributors include Meg Warder, Martha Linde, Robert M. Ovnicek, Mick Winn, Alan L. Rosenburg, and Dr. Kenneth O. Leonard. Thanks to members of the Balloon Historical Society: Ed Yost, Christine Kalakuka, John S. Crapara, Col. Joe Kittinger Jr., and Rev. Arley Fadness. Additional thanks to the Ruby House Restaurant and Powder House Lodge, Steve and Linda Zwetzig, Beautiful Rushmore Cave, John and Cindy Esposito, Rushmore Aerial Tramway, Mark and Vivian Fullerton, Black Hills Central Railroad (1880 train), Meg Warder, Rushmore Helicopters, Bruce and Margie Schlitz, Black Hills Souvenirs and Gifts, Dean and LaVeta Giannonatti, National Presidents Wax Museum, Justin Cutler and Nellie Isaacs, Big Thunder Gold Mine, Sandy McLain, Alpine Inn, Monika Mechling, Landstrom's Jewelry, John Houser, and Delores Hallsted Long. Many thanks to those who provided historical information and advice, including Bill Groethe, David Sipple, Donna Neal, and Craig Stump. Special thanks to Rex Alan Smith for answering numerous questions and for the detailed information in his book *The Carving of Mount Rushmore*. Also thanks to authors Gilbert Fite (*Mount Rushmore*) and Howard and Audrey Karl Shaff (*Six Wars at a Time*).

Finally, the authors would like to acknowledge the patience and care extended by their families. Robert E. Hayes would especially like to acknowledge his wife, Barbara; while Tom Domek would especially like to acknowledge his three oldest children, Bob, Sadie, and Jennifer. Their families are a continual source of energy and inspiration.

INTRODUCTION

Long before settlers poured into the Black Hills, American Indians occupied this beautiful mountainous region. The discovery of gold along French Creek in 1874, however, brought a new cultural influence. By 1876, prospectors were placer mining along Battle Creek, leading to the settlement of Harney City (now a ghost town), not far from where Keystone would later be platted. Fred Cross was probably the first permanent settler in the area, setting up a cabin in Buckeye Gulch in 1877. In 1883, the Harney Peak Hydraulic Gold Mining Company was organized to work gold-rich gravel beds along six miles of Battle Creek. The company built one flume from two tributaries to transport water from both Battle and Grizzly Bear Creeks. One leg of the flume included a 700-foot-long trestle suspended 200 feet in the air above the confluence of the two creeks.

The Etta Mine was also located in the area in 1883 and was known for its mica and cassiterite (tin oxide) ores. Over the next 10 years, the Harney Peak Tin Company acquired more than 1,100 mining claims in the area and built three reduction plants to process its ores. Because the company paid decent wages, gold mining fell off for a spell. Then, in 1891, William Franklin, Thomas Blair, and Jacob Reed located the Keystone Mine, the same year Keystone was organized. Within a couple years, a rich ledge of gold-bearing quartz was discovered at the base of Mount Aetna. Franklin and Blair set claim to the site on June 28, 1894, naming it the Holy Terror Mine. The Holy Terror quickly became one of the richest gold-producing mines in the southern Black Hills.

By the beginning of the 20th century, Keystone was the largest city in Pennington County, with more than 2,000 people. The Chicago, Burlington and Quincy Railroad reached Keystone on January 20, 1900, increasing mine development. Over the next 50 years, the railroad hauled such minerals as feldspar, spodumene, and amblygonite out of Keystone.

For several years, Franklin, Blair, and their partners profited well from the Holy Terror, but not before the mine claimed several lives and attorneys were arguing in court over ownership of the mine. By 1903, the owners threw up their hands and closed the mine they had financed to a depth of 1,200 feet. Economic depression and devastating fires (in 1908, 1917, 1921, and 1937) followed in Keystone.

Finally, the town's economy began to rebound in 1924. Reduced freight rates contributed to the commercial mining of feldspar and led to the construction of a grinding plant in 1928. Beginning that same year, gold mining flourished for a spell because the gold ores recovered from the Bullion Mine contained enough arsenic to warrant construction of a reduction plant used to remove both the gold and arsenic.

But nothing stabilized Keystone's economy more than the carving of Mount Rushmore. In 1924, Doane Robinson, South Dakota's state historian, invited sculptor Gutzon Borglum to the Black Hills. Robinson hoped that Borglum would agree to carve a major sculpture in Black Hills granite. Such a project, Robinson reasoned, would greatly enhance South Dakota tourism. The following year, Borglum arrived in the Black Hills and soon settled on a gargantuan wall of granite near Keystone called Mount Rushmore.

Borglum expressed his vision for Mount Rushmore in 1925: "I want, somewhere in America . . . a few feet of stone that carries the likenesses . . . of the great things we accomplished as a Nation, placed so high that it won't pay to pull it down for lesser purposes." In earnest, Borglum molded his vision into plaster of paris models. Not long after, on August 10, 1927, Pres. Calvin

Coolidge visited Mount Rushmore and spoke of "a cornerstone . . . laid by the hand of the Almighty." At the end of Coolidge's speech, Borglum climbed to the top of the mountain and drilled holes to outline the bust of Washington.

Borglum could not, of course, carve the mountain alone, yet other professional sculptors were not available. Instead, he turned to Black Hills miners. During the carving years, between 1927 and 1941, Borglum employed some 25 to 35 men each year. These common men with an uncommon mission scaled walls of granite, operated drills, and blasted tons of granite from the mountain.

Year after year, the work continued. In 1930, the face of George Washington was unveiled from behind a huge American flag. In 1936, during a visit from Pres. Franklin Roosevelt, Thomas Jefferson's head was unveiled. The following year, Abraham Lincoln's face was revealed, and in 1939, the upper half of Theodore Roosevelt's head was unveiled during South Dakota's Golden Jubilee. Unfortunately, Borglum would never see Roosevelt's face appear in full. The irascible Borglum, who was 60 when the project began, died of heart failure in March 1941. His son, Lincoln, completed the image of Roosevelt. Then, with the nation edging toward war, the blasting, drilling, and climbing ended and the carving of Mount Rushmore was no more.

Before the carving was completed, Keystone's tourism industry had taken off. A flush of road building brought thousands of tourists through Keystone to Mount Rushmore, and merchants were setting up shop. Perhaps the first tourist outlet of consequence in Keystone was the Hesnard Museum. Josephine Hesnard and Rose Reddick built a rock and mineral building next to the new Highway 16, which was routed through Keystone along Winter Street. The partners also provided mine tours and guided tourists into the Krupp Tunnel, which today is known as the Big Thunder Gold Mine, and its pegmatite mines.

Permaclay Ceramics, later known as Rushmore Pottery, was another early tourist business that helped characterize Keystone. Today, Permaclay Ceramics no longer exists, but the signature Rushmore Pottery remains highly collectible. As time wore on, other businesses sprang up along Winter Street—so many, in fact, that the lane was soon bluntly known as "The Strip".

Another important event occurred in the central Black Hills in the mid-1930s. The National Geographic Society and the U.S. Army launched two high-altitude balloons, one in 1934 and the other in 1935, from the Stratobowl, a deep, natural limestone depression not far from Keystone. The scientific data collected during the record-breaking flights helped launch the space industry and brought a great deal of attention to the Black Hills.

Meanwhile, international turmoil and the gradual march toward World War II pushed the demand for minerals. Between 1938 and 1942, gold mining was revived in Keystone. Commercial hard rock minerals, as well, were in great demand, including feldspar, mica, beryl, tantalite, columbite, amblygonite, lepidolite, spodumene, and quartz. Since that era, however, mining activity has gradually declined. Keystone's feldspar grinding plant burned down in 1957. Later, in June 1972, a treacherous flood swept through the central Black Hills, killing 22 people in Keystone alone and destroying Keystone's railroad infrastructure. All the deaths were visitors who were camped along the streams. Today, quartz is the only viable hard rock mineral commercially crushed and bagged in the Keystone area.

Today, tourism has replaced mining. Mount Rushmore receives more than 3 million visitors each year. Most of them travel through and shop in Keystone. Business is brisk. And above it all—above the merchants, the tourists, and a sleepy little town that grows 15,000 fold in summer—is Mount Rushmore, one of the most enduring, most loved, and most visited symbols of democracy, patriotism, and enterprise in America.

One

EARLY KEYSTONE, GOLD AND HARD ROCK MINING
(1876–1925)

Keystone has had its share of celebrities with either close or tenuous ties to the area. One such celebrity was Samuel Clemens, who is perhaps better known by his pen name, Mark Twain. In this *c*. 1860 photograph, Clemens is shown in the center, flanked by his friends and associates, A. J. Simmons (left) and William H. Claggett (right). Simmons and Clemens were roommates in Aurora, Nevada. All three men were involved in the Nevada Territorial Legislature. While Clemens was an astute commentator on Nevada's legislative proceedings, Simmons was a member of the territory's House of Representatives, as was Claggett. After hitting it rich in Montana, both Claggett and Simmons came to Deadwood in 1878. Mark Twain once came to Deadwood to visit his friends. In 1883, Claggett became president of the newly formed Harney Hydraulic Gold Mining Company in the Keystone area; Simmons worked as an organizer for the company. The company mined placer deposits along six miles of Battle Creek. Several years later, Simmons would announce the discovery of tin at the Etta Mine. He also served as the first superintendent of the Keystone Gold Mining Company. (Photograph courtesy of the University of Nevada-Reno.)

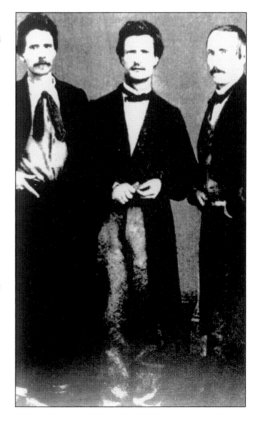

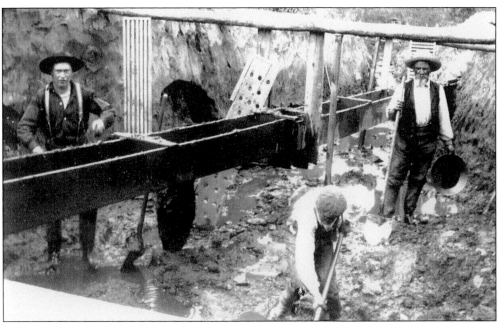

This photograph shows a group of miners around 1876, working the gravel deposits along Battle Creek. Such placer miners put in grueling hours in ice-cold streams just to make their wages in gold. The first placer miners to probe the central Black Hills probably arrived in 1875. Placer mining was fairly simple. The miners would shovel gravel into a sluice box, then, using nearby water, the miners would wash the water over the gravel in the sluice box. The heavier gravels would collect along riffles in the box; lighter materials would drain out the end. After the heavier materials were collected from the riffles, the miners would pan them in the nearby stream water. (Photograph by Alice Ozmun.)

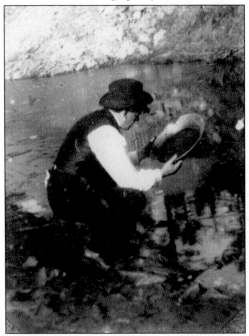

This undated photograph shows a typical miner looking for "color" in his gold pan. Color refers to the flakes of gold found in gravel deposits. Although rumors of gold in the Black Hills had long circulated nationwide, the existence of gold was not proven until Lt. Col. George Custer led a military and exploratory expedition into the Black Hills in 1874. Miners attached to his command discovered color along French Creek near what is now the town of Custer. News of the discovery swept the nation, and despite treaty obligations with the Lakota (Sioux), gold seekers swept into the Black Hills, creating a mad rush for gold and precipitating the last significant war between the U.S. government and the Lakota nation. (Photograph by Alice Ozmun.)

In the fall of 1875, Sheridan was laid out as the third town established in the Black Hills, following Custer and Hill City. The small community was at first called Golden, but was soon renamed Sheridan in honor of Gen. Phil Sheridan. Sheridan was the first county seat of Pennington County. The log cabin shown in this undated photograph sat at the heart of Sheridan. Today, Sheridan is a watery ghost town, lying at the bottom of man-made Sheridan Lake in the central Black Hills. (Photograph courtesy of Robert E. Hayes.)

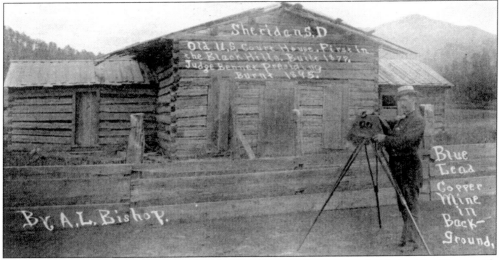

In 1877, the first term of the Black Hills Circuit Court was held in Sheridan, with Hon. Granville G. Bennett presiding. The court convened in the large log building shown in this photograph. The building stood until a fire consumed it in 1895. During the opening session of the court, several Deadwood attorneys were present but were compelled to sleep on the floor of the log building, since accommodations were scarce in Sheridan. Can anyone imagine attorneys sleeping under such austere conditions today? A frontier photographer stands next to his camera and tripod in this undated photograph. (Photograph courtesy of Robert E. Hayes.)

Fred Cross was possibly the first permanent settler in the Keystone area, setting up residence in 1877. Cross was born in New York in 1835 and grew up in the wilds of Ohio. He met tragedy early when he lost his wife and three daughters to black diphtheria in just one week. He later moved to the Dakota Territory and was appointed the first register of deeds of Custer County. Cross staked out seven mining claims and brought the first stamp mill into the Keystone area. Cross died on April 18, 1910, almost penniless. (Photograph courtesy of Alan L. Rosenburg.)

This photograph shows the cabin home of Fred Cross located in Buckeye Gulch, a setting that was soon known as Crossville. Cross once lived in Ohio, which led to the naming of Buckeye Gulch. (Photograph courtesy of Alan L. Rosenburg.)

Maj. A. J. Simmons (shown in this undated photograph), along with William Claggett and T. H. Russell, organized and incorporated the Harney Hydraulic Gold Mining Company in 1883. Their goal was to reach deep gold-laden gravel beds along Battle Creek using hydraulic mining techniques. They recovered considerable gold through the process over the ensuing one and a half years. (Photograph courtesy of Robert E. Hayes.)

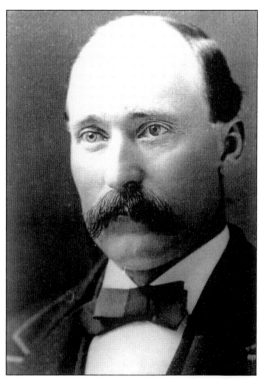

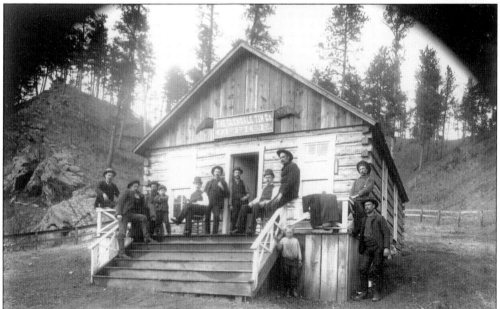

The Glendale Tin Company, shown here around 1887, was located in Glendale (now a ghost town) four miles southeast of Keystone on Iron Creek. Glendale was part of the "tin boom" in the Black Hills from 1883 to 1893. This boom brought New York attorney Charles Rushmore—for whom the mountain is named—to the Black Hills. Three reduction plants were built to process tin: Glendale, Hill City, and the Etta Mine in Keystone. (Photograph courtesy of the Minnilusa Pioneer Association.)

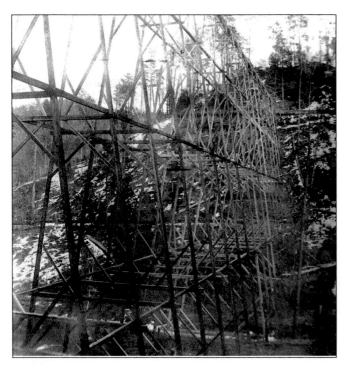

This trestle is the Battle Creek leg of a flume crossing Grizzly Bear Creek. The trestle was located over what is now Keystone's Post Office and Ruby House Restaurant. The flume delivered water to the Mitchell sandbar, where placer gold was washed by hydraulic means. The trestle was 700 feet long and 200 feet above the stream. The woodchute can be seen in the far background of this *c.* 1885 photograph. It was so named because wood was sent down a chute to feed the boilers, at the Holy Terror Mine and Mill, which provided steam power. (Photograph courtesy of Dr. Kenneth O. Leonard.)

The trestle, shown here around 1885, is part of a flume that carried water to Mitchell Bar (a sandbar). The Harney Hydraulic Gold Mining Company mined gold from the Mitchell Bar. The water, under hydraulic pressure, was used to wash the sand away, leaving the heavier gold behind. In the photograph, the trestle crosses Grizzly Bear Creek. The trestle is 700 feet long and 200 feet above the creek bed. Mount Aetna can be seen in the background, so named by Sicilian miners. (Photograph courtesy of the Minnilusa Pioneer Association.)

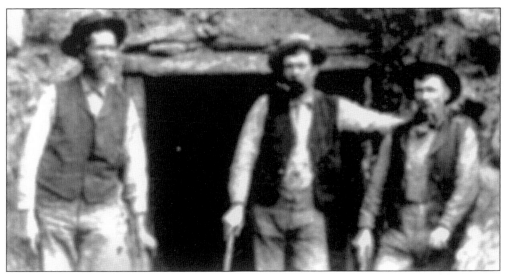

The Keystone Mine was the first lode claim in Keystone to operate and produce gold in paying quantities. The locators of this mine pose in this c. 1892 photograph at the portal to the mine. The men, from left to right, are Jacob Reed, Tom Blair, and William "Bill" Franklin (also known as Rocky Mountain Frank). Jacob Reed was the father-in-law of Tom Blair. (Photograph courtesy of Mary Dickerson and Mick Winn.)

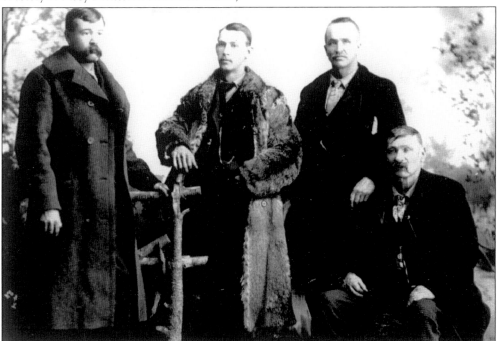

The original "Big Four" of the Holy Terror Mine are shown in this c. 1895 photograph. They are, from left to right, Tom Blair, Fred Amsberry, John Fayel (manager), and Bill Franklin, who named the mine—jokingly—after his wife. Blair and Franklin located the mine and gave one-half interest to Amsberry and Fayel to finance the development of the mine and build a ten-stamp mill. Amsberry later committed suicide in Washington, D.C. (Photograph courtesy of Robert E. Hayes.)

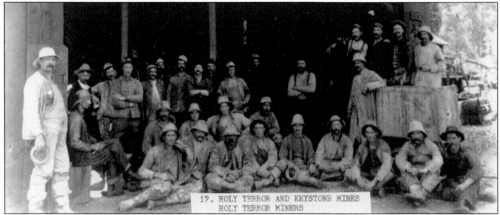

17. HOLY TERROR AND KEYSTONE MINES
HOLY TERROR MINERS

Miners pose around 1898 outside the Holy Terror Mine, probably the richest gold mine ever worked in the southern Black Hills. The mine was located on June 28, 1894. It was closed less than 10 years later, in July 1903, after reaching a depth of 1,200 feet. Closure was due to numerous court actions arising from mining accidents and fatalities, questions of ownership, and the excessive cost associated with pumping water out of the mine. (Photograph courtesy of the Halley collection.)

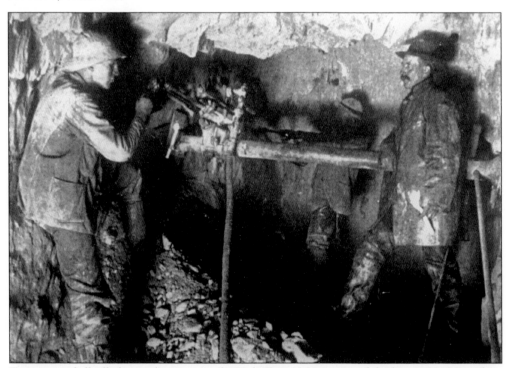

Two miners drill off of a crossbar setup in the Holy Terror Mine, around the late 1890s. Note their wet clothing, indicating how damp it became underground. The miner on the right is Andrew Miller. He died in the mine on October 22, 1901, after a fire in a compressor cylinder pumped carbon dioxide into the mine. Two other miners—Lewis Crouter and Pete Polman—perished in the same accident. The miner shown at left in the photograph is Billie Clifford. Miller and Polman are buried in the Mountain View Cemetery in Keystone. Crouter is buried in Custer. (Photograph courtesy of Robert E. Hayes.)

16

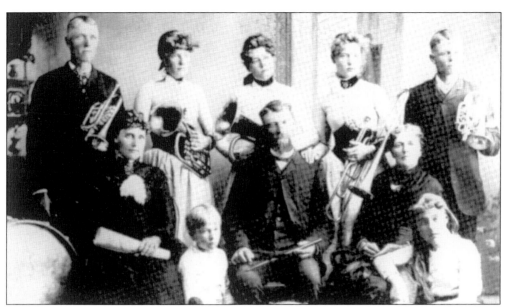

Keystone's Bower Family Band poses for a photograph in Vermillion, Dakota Territory, around 1875, prior to coming to the Black Hills. From left to right, they are (first row) Alice, Laura, father, mother, and Quinie; (second row) Sidney, Nettie, Lulu, Rose, and Mayo. Alice married Joe Gossage, founder of the *Black Hills Journal* (later *Rapid City Journal*). By the 1880s, the family was homesteading on lower Battle and French Creeks. Laura Bower Van Nuys wrote a biography of the family, which Walt Disney Studio made into a movie, *The One and Only, Genuine, Original Family Band*, in 1968. Walter Brennan, Buddy Ebsen, and Lesley Ann Warren, among others, starred in the movie. (Photograph courtesy of Laura Bower Van Nuys.)

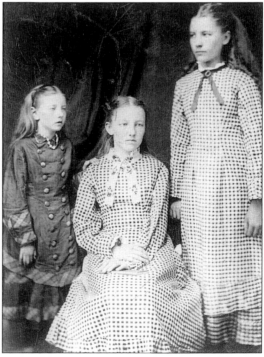

Three Ingalls girls of *Little House on the Prairie* fame pose around 1877. From left to right, they are Carrie, Mary, and Laura. Laura Ingalls Wilder is the world-renown author. Carrie Ingalls came to Keystone in 1911 to work for Keystone's newspaper, the *Recorder*. She remained in Keystone until her death in 1946. The Keystone Historical Museum features memorabilia of Carrie's and organizes an annual event in her memory. (Photograph courtesy of the Keystone Historical Museum.)

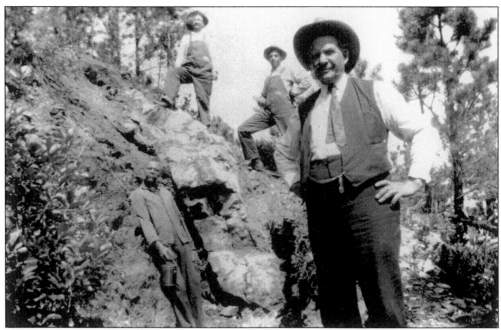

Col. James "Big Hat" Clark, seen at the front of this photograph, taken around 1900, promoted investment opportunities in the Keystone area to Eastern capitalists. In a prospectus for stocks to the Golden Return Mine, Clark claimed mining experience from Mexico to Canada. He called his home Rosedale. (Photograph courtesy of Robert E. Hayes.)

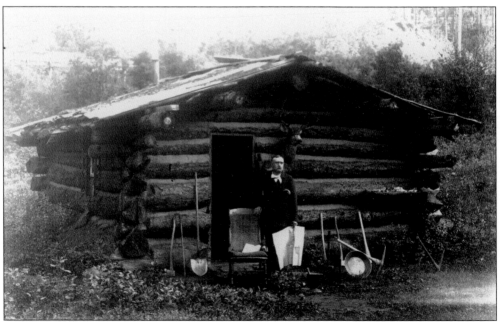

This c. 1900 photograph depicts a typical home for a single miner. The miner in front of the cabin is Hiram "Gaston" Leonard. Note the mining tools in front of his cabin. Gaston appears well dressed for a miner. (Photograph courtesy of the Minnilusa Pioneer Association.)

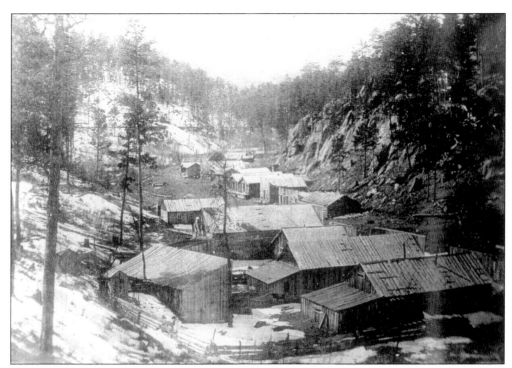

This *c*. 1890 photograph shows the Etta Camp, adjacent to Etta Mine. The remains of Etta Camp are found on the southern end of Keystone. In the early 1890s, J. K. Mills carried mail from Hermosa to Keystone via the Etta Camp. The Keystone Post Office has seen continuous service since May 8, 1891. (Photograph courtesy of Robert E. Hayes.)

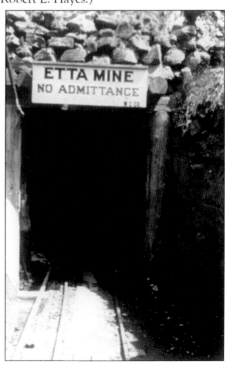

This *c*. 1926 photograph shows the portal to the Etta Mine, which was a mica mine, located in 1883. Soon after 1883, a black ore was discovered inside the mine. A small amount of the ore was melted in a common forge. Miners at first thought the ore was silver, but tests conducted by professor Hullbrecken of Quincy, Illinois, soon indicated that the black ore was cassiterite, otherwise known as tin. A brief "tin boom" in Keystone followed. The Etta Mine ceased operations in the mid-1950s. (Photograph courtesy of Robert E. Hayes.)

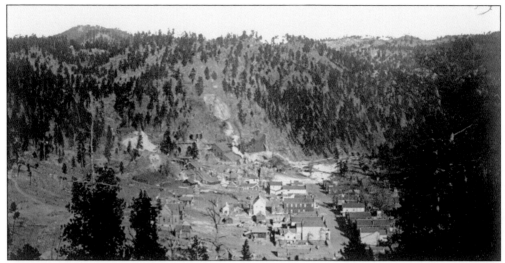

This photograph shows Keystone around 1900. The Holy Terror Mine and Mill can be seen on the left while the Keystone Mine and Mill can be seen in the center. Battle Creek flows to the right of center towards the communities of Harney, Hayward, and Hermosa, and eventually drains into the Cheyenne River. (Photograph courtesy of O. A. Vik Studios.)

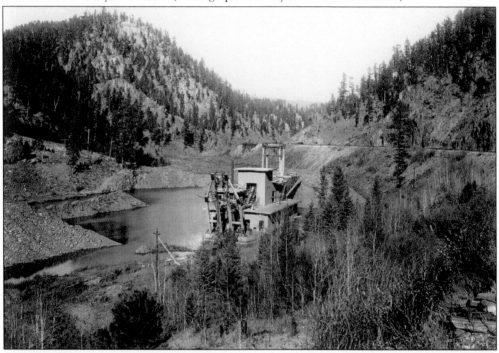

A gold dredge works Castle Creek outside Mystic, South Dakota, in this *c.* 1900 photograph. Steam powers the dredge and gold mill, which floats on its own pool of water. A bucket conveyor dredges—or digs—the gravel from the stream, while miners in the mill extract the gold from the gravel. Barren materials are then dumped out the back of the dredge via a separate conveyor. Note the railway track operated by the Chicago, Burlington and Quincy Railroad shown to the right and back of the dredge. Mystic is located less than 20 miles northwest of Keystone. (Photograph courtesy of Robert E. Hayes.)

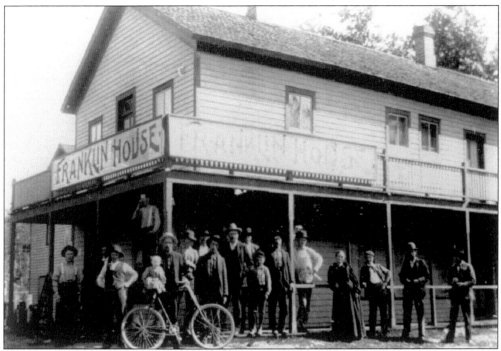

A large group poses for a c. 1895 photograph outside the Franklin House at the northeast corner of Franklin and Main Streets. The Franklin House was owned and operated by William and Jennie Franklin. The owners catered to common folks and semi-permanent guests, while the McDonald Hotel, across Main Street, catered to travelers and mining tycoons—or at least those who considered themselves tycoons. (Photograph courtesy of Robert M. Ovnicek.)

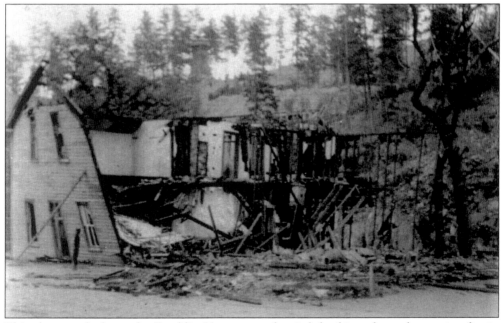

This photograph shows the Franklin House—or what is left of it—after a devastating fire in 1908. (Photograph courtesy of Rober M. Ovnicek.)

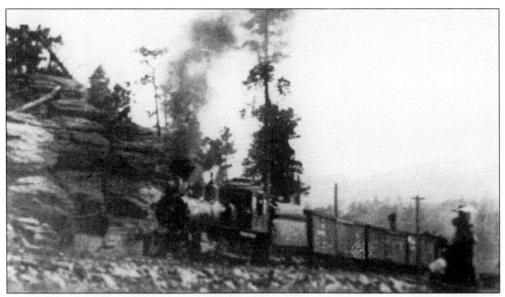

A steam engine pulls freight up the grade from Keystone to Hill City around 1900. The grade around Pine Camp (Camp Judson) outside Keystone measures four percent for several miles. A four percent grade means that a train gains four feet of elevation for every 100 feet of travel. Four percent is steep by railway standards. (Photograph by Alice Ozmun.)

A steamer stops on a trestle somewhere in the central Black Hills around 1900. The arrival of the Chicago, Burlington and Quincy Railroad in Keystone in January 1900 invigorated the mining industry, which thereafter had a reliable means to transport minerals, products, and supplies. (Photograph courtesy of the Hesnard collection.)

This c. 1910 photograph shows the Hugo Mine, located for amblygonite by Dr. Herman Reinbold, who was educated at the University of Heidelberg in Germany. The Hugo was named for Herman's son, Hugo Reinbold. Amblygonite has been mined extensively in South Dakota as an important lithium ore. Amblygonite has a larger concentration of lithium than spodumene. Note how the ore was transferred from an upper level by means of an enclosed chute. (Photograph courtesy of Robert E. Hayes.)

This undated photograph shows an open cut at the Hugo Mine. Note the tarp shown at the lower right. Miners hung such tarps to create shade for themselves. Temperatures can rise precipitously in warmer months when the sun reflects off of exposed rocks and ores. Railway tracks, 18 inches in width, are shown in the photograph and were used to transport the ore in one-ton mine cars, which were pushed by hand. Feldspar was the main ore taken from the Hugo Mine, although it was originally located for the production of amblygonite. (Photograph courtesy of Robert E. Hayes.)

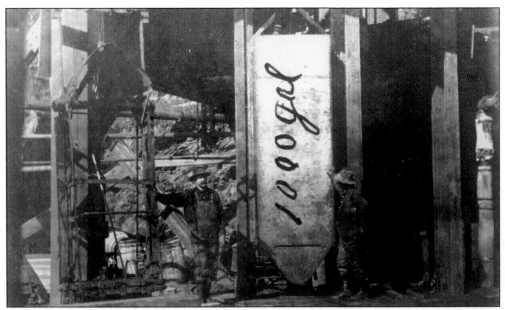

The Holy Terror Mine was shut down in July 1903. An attempt to un-water the mine was conducted in 1907 or 1908. Two skips that held 1,000 gallons were used to hoist the water, which was discharged into nearby Battle Creek. The skips were counter-balanced; that is, while one dropped down into the shaft, the other rose toward the surface. This project was abandoned before it could be successfully completed. This photograph shows two men standing next to one of the skips at the surface of the Holy Terror Mine. (Photograph courtesy of the Minnilusa Pioneer Association.)

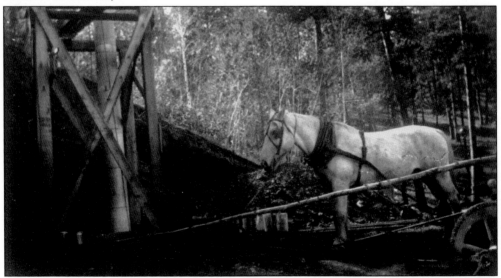

This c. 1905 photograph depicts a horse whim pulling ore out of the Nathaniel Pope Mine in Rocky Gulch, which was earlier called Rattle Snake Gulch. Note the cable (wire rope) and pulley. The horse travels in a circle, pulling a lever that wraps the cable around a vertical drum. The cable runs under a platform so the horse can make a complete circle. There was no electrical power in Keystone until 1927, so horse power—as well as steam power—was essential. (Photograph courtesy of Robert E. Hayes.)

This undated photograph offers an overview of the Hugo Mine. Feldspar—used to make glass, porcelain, and false teeth—was the main ore mined. Other minerals extracted from the Hugo Mine included beryl, columbite, and muscovite (mica). These strategic minerals were sought after during World War II, and the Hugo Mine operated in two shifts, seven days a week. The building in the foreground—lost during the 1972 flood—housed the post office in Etta Camp until 1891. (Photograph courtesy of Robert E. Hayes.)

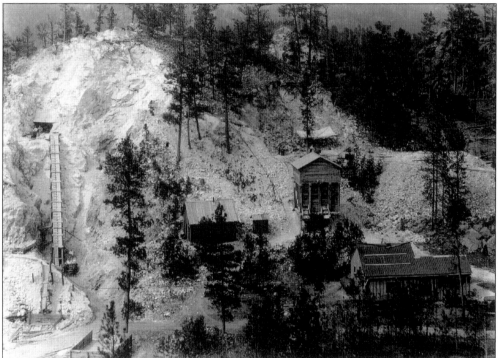

This photograph, taken around 1923, shows the Hugo Mine's open cut toward the left and its waste dump toward the right. One-ton ore cars would be filled with feldspar within the mine, then dumped into an ore bin. A dump truck would then transfer the feldspar to a grinding plant, where the ore would be ground into a powder finer than flour. Railway cars would later carry the ground feldspar to manufacturing plants out East. (Photograph courtesy of Robert E. Hayes.)

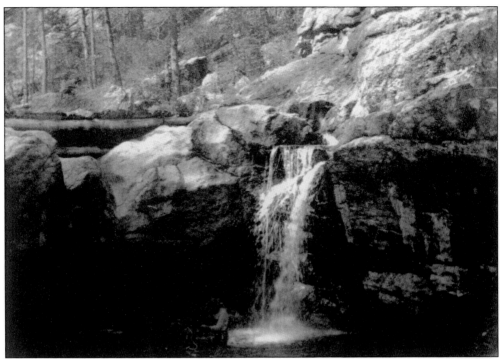

This photograph, likely shot before 1900, shows a man, bottom center, below "Big Falls," along Battle Creek between Harney and Hayward. (Photograph by Alice Ozmun.)

A woman sits beside a small waterfall along Battle Creek, probably upstream from Hayward. The photograph was probably taken before 1900. (Photograph by Alice Ozmun.)

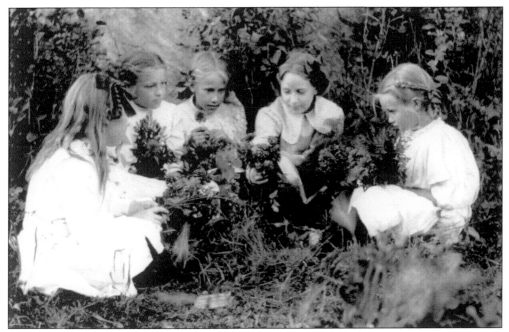

Five girls sit in a circle admiring each other's freshly picked bouquets of wildflowers. This photograph, taken by an early Keystone resident and pioneer photographer—Alice Ozmun—was likely taken before 1900. (Photograph by Alice Ozmun.)

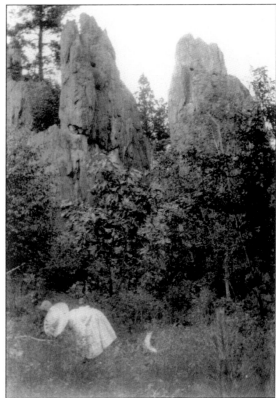

Granite spires tower above women enjoying the flush of summer wildflowers and greenery around 1890. (Photograph by Alice Ozmun.)

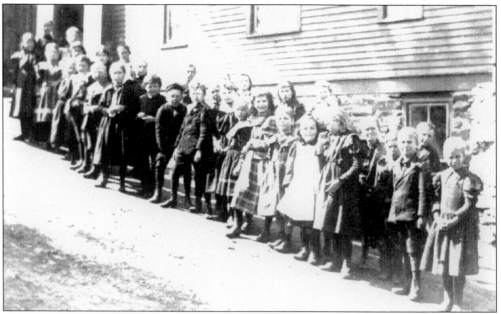

Before 1900, a small log cabin and Willis Bower's private school both grew too crowded to serve families with schoolchildren. Rose Bower approached the board of the Keystone Congregational Church and received permission to hold school in the basement of the church. This c. 1898 photograph shows the school's students posing outside the church. (Photograph courtesy of the Laura Bower Van Nuys's collection.)

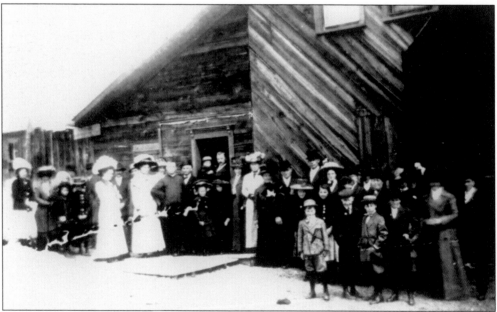

Parishioners gather for a c. 1910 photograph after mass outside the Bobier house. Roman Catholics held mass in Baldwin's Hall until a fire in 1908 destroyed the east side of Main Street in Keystone. After the fire, John Hayes built an altar in the abandoned John Bobier house. In 1918, Our Lady of Mount Carmel Church was built on Blair Street by John Hayes to serve Catholics living in the Keystone area. (Photograph courtesy of Robert E. Hayes.)

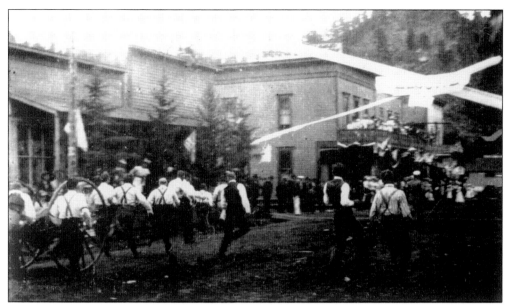

This photograph, taken on July 4, 1900, depicts a hose cart race on Keystone's Main Street. Trees decorated the side of the street for the festive occasion. (Photograph courtesy of the Laura Bower Van Nuys's collection.)

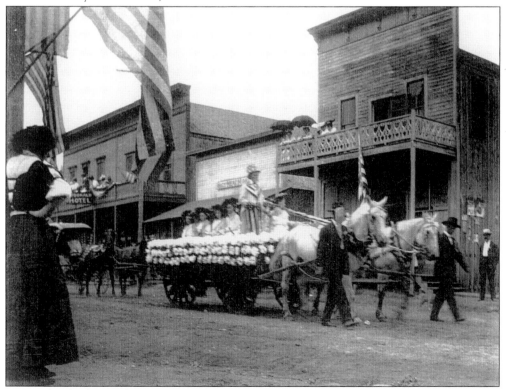

A Fourth of July parade in 1900 rolls down Main Street in Keystone. Calvin Bower, of the Bower Family Band, rides in the float as Uncle Sam. Young girls on the float represent the states. (Photograph courtesy of the Laura Bower Van Nuys's collection.)

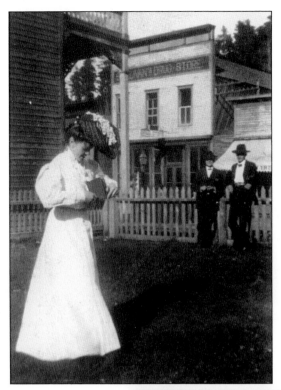

Two men, far right, pause to admire an elegantly dressed lady in downtown Keystone around 1900. Note Sullivan's Drug Store across the street. (Photograph courtesy of Robert M. Ovnicek.)

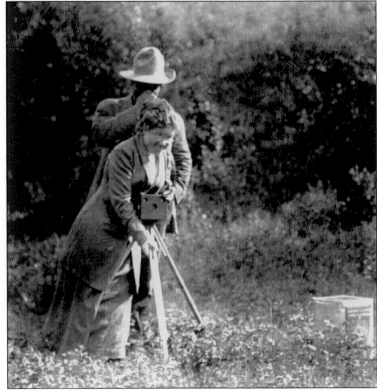

Maggie Darling sets up her camera on a tripod in this early, but undated, photograph. The man behind her may be Jock Snowie. (Photograph courtesy of the Maggie Darling collection.)

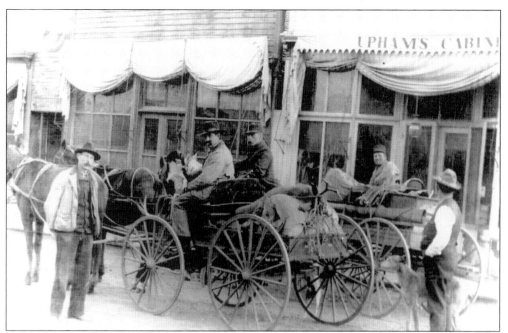

Horse-drawn wagons were the primary form of transportation during the early days of Keystone. This c. 1900 photograph was probably taken on the east side of Main Street before fire destroyed the buildings in the background. Note the sign above the store window, which says Upham's Cabinet Shop. (Photograph courtesy of Robert E. Hayes.)

A couple, in horse and buggy, smile for the camera around 1900. (Photograph courtesy of Robert M. Ovnicek.)

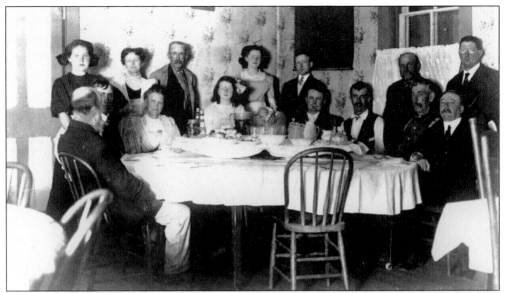

The owners of the McDonald Hotel had trouble hiring domestic help. In lieu of help, they placed this unique table in their hotel. On top of a large stationary table was a smaller revolving table about seven and a half feet in diameter where food was set. As the table was turned, guests helped themselves. Pictured around 1911, from left to right, are (first row) Abe Boland, Lawrence Suko, Mrs. Abe Boland, Nellie Hazeltine, Roy Hainer, Jerry Spriggs, Hiram Leonard, and Dr. Herman Reinbold; (second row) Lilian (Stevens) Culver, Edith Hazeltine, Bert Lane, Kathryn (Fallon) Hazeltine, John Boland, Edward M. Davis, and an unidentified mining friend. (Photograph courtesy of Martha Linde.)

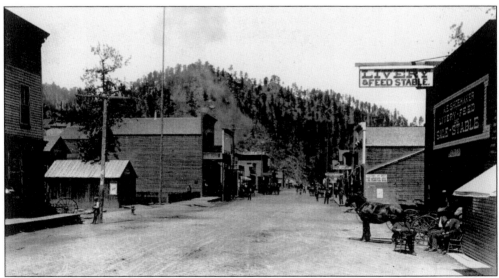

The camera in this c. 1900 photograph points north on Keystone's Main Street. To the left is a corner view of Abe Boland's feed store. The next two-story building is the Masonic lodge. At the far end of the street is the McDonald Hotel. On the far right is Al Shoemaker's livery stable. The building next to the livery stable is Charlie Upham's saloon. Drs. Smith and Ratte had their office on the second floor of Abe Boland's feed store. (Photograph courtesy of Robert E. Hayes.)

A boy carries a rabbit he just shot on the east end of Keystone around 1895. (Photograph by Alice Ozmun.)

A granite monolith rises from a meadow on the Hesnard Ranch south of the Etta Mine around 1890. The team shown is mowing hay. (Photograph by Alice Ozmun.)

Stewart Edward White, Ph.D., was a paymaster at one of the Keystone gold mines before 1900. The mine, short of funds, could not meet its payroll. The company's miners, drinking hard in a saloon, decided that if the paymaster could not pay them, then perhaps they should collect the debt through the noose of a rope. Whether the miners were serious or not, White hightailed it out of town. The former paymaster went on to write western novels, including *The Westerners* and *The Claim Jumpers*, both set in the Keystone locale. (Photograph courtesy of the Keystone Historical Museum.)

This building is identified on the back of this photograph as Eastman Sawmill, of which little is known or written. It was likely located somewhere outside Keystone. Lumberjacks have long harvested the ponderosa pine and other woods in the Black Hills. (Photograph courtesy of the Halley collection.)

This photograph depicts Keystone's Main Street looking south in 1916. By then, horseless carriages were beginning to drone through the heart of Keystone. (Photograph courtesy of Robert E. Hayes.)

This photograph, taken in 1916, shows the Custom Mill, later called the Tykoon Mill, at the top center. Note the swayback bridge. The bridge was elevated above Battle Creek so that teams pulling ore wagons would not have to go down to creek level and back up the hill. To the right of the bridge is the blacksmith shop originally owned by Joe Hayes. At the time of this photograph, the bridge was in a state of deterioration, as the mill was idle for many years. To the far right is Al Shoemaker's livery stable. (Photograph courtesy of Robert E. Hayes.)

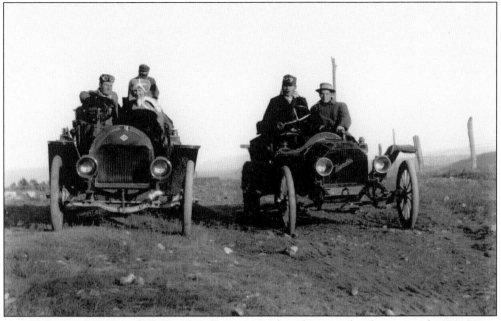

Two early motorists top a hill along Highway 16 in this photograph taken around 1909. James Halley III is behind the wheel of his Hupmobile (on the right) on his way to Keystone. Note that the steering wheels of both vehicles are set to the right. (Photograph courtesy of the Halley collection.)

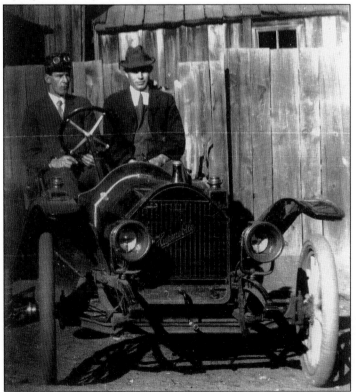

James Halley and Ernest Engel prepare for a ride in Halley's Hupmobile around 1910. Halley brought the first horseless carriage to Keystone. Engel was a prominent mining man and had an association with the Bismark and Ida Florence Mines. Ernie's father, August Engel, and Fred Sierth owned the Bismark Mine. The latter two, both from Germany, drove the Krupp Tunnel, or Adit, now called the Big Thunder Mine. (Photograph courtesy of the Halley collection.)

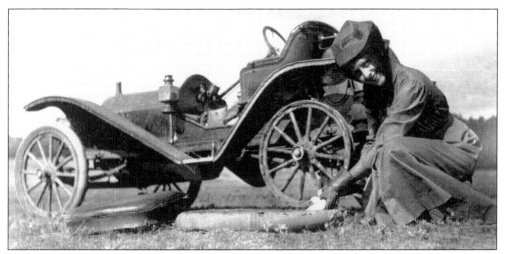

Early auto travel in the Black Hills was difficult, but nothing a good hand with a wrench could not overcome. In this *c.* 1917 photograph, an unidentified woman cheerfully swaps a tire on her touring vehicle. (Photograph courtesy of the Halley collection.)

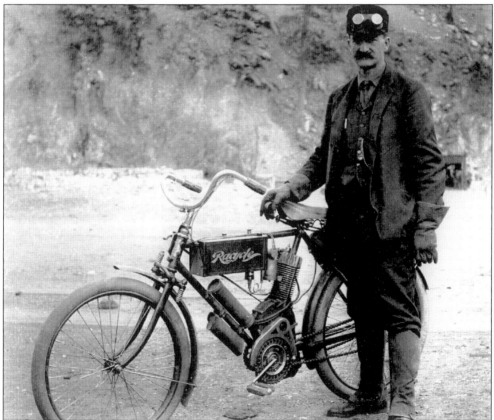

Dick Carolyon poses next to his motorized bicycle around 1911. The bike was apparently called a Raycycle. This photograph might have been taken in the winter, judging from Carolyon's heavy clothes and gloves. Carolyon was a longtime barber in Keystone. (Photograph courtesy of the Halley collection.)

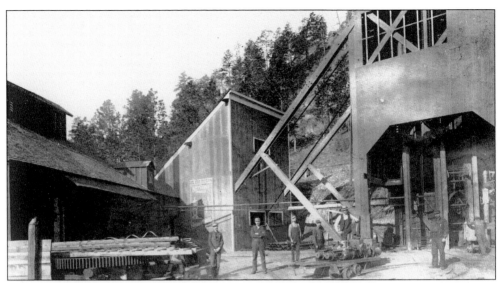

This photograph shows the Holy Terror around 1898. The head frame, or "gallows frame," is on the right while the hoisting works are in the center. Two compartment shafts served the mine. Two counterbalanced cages were used to hoist men, ore, and equipment. One skip would come up as the other went down, saving a great deal of energy. (Photograph courtesy of the Minnilusa Pioneer Association.)

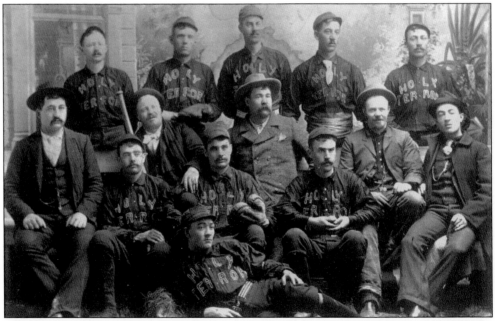

The Holy Terror Mine sported a baseball team in the 1890s and possibly later. Unfortunately, the mine closed in July 1903, and many families left Keystone. At the time of this photograph, around 1895, no one recorded the players' names. The Hayes family later identified several of the men. From left to right, they are (first row, lying down) Walt Canfield; (second row) James Hopkins, Patrick Hayes, John Hayes, and George Coats; (third row) unidentified, Tom Blair, and two unidentified men; (fourth row) unidentified, Ed Cessna, and three unidentified men. (Photograph courtesy of Robert E. Hayes.)

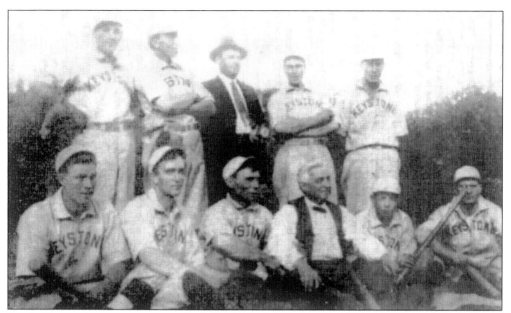

Baseball was a favorite pastime in Keystone. This 1915 photograph, titled the "Keystone Nine," pictures, from left to right, (first row) Steve Watson, Irvin Harold, Herb Atchison, Tom Hoy (co-manager), Duke Peterson, and Byron Hazeltine; (second row) Ray Virtue, Fred Schermer, John Hayes (co-manager), Loren McDonald, and Ralph Smith. (Photograph courtesy of Robert E. Hayes.)

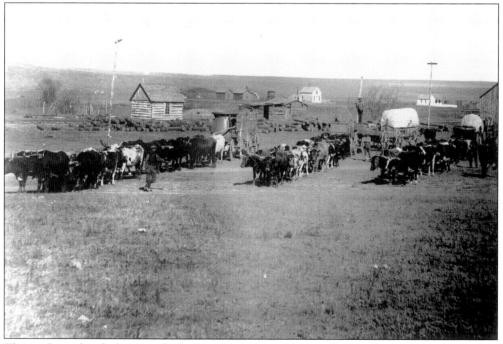

This early undated photograph depicts three oxen teams and their drovers carrying mining equipment toward the Black Hills. Note the number of oxen required to pull these freight wagons across the countryside. (Photograph courtesy of the Minnilusa Pioneer Association.)

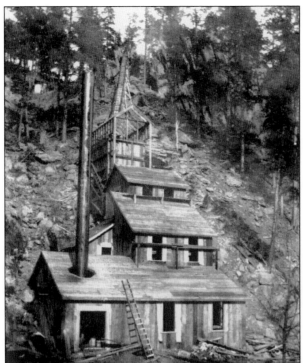

This *c.* 1917 photograph shows the ruins of the Blue Bird Mill, which was remodeled to extract gold ore mined from the Bullion Mine. An arsenic concentrate was sent to the arsenic plant to extract arsenic in what the miners called "kitchens." (Photograph courtesy of Robert E. Hayes.)

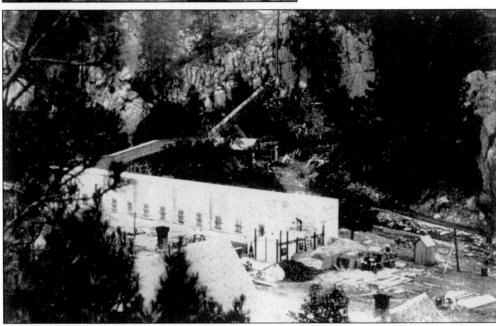

This photograph shows the Keystone Arsenic Company, which had the best of two worlds in 1924. The company mined gold-bearing arsenopyrite from the Bullion Mine, extracting the gold in the Blue Bird Mill. An arsenic concentrate was roasted in the plant shown in the photograph, and the extracted arsenic was sent south where it was used to kill boll weevils in the cotton fields. The arsenic poison was so effective that the price of arsenic plummeted and the plant was forced to shut down. (Photograph courtesy of Robert E. Hayes.)

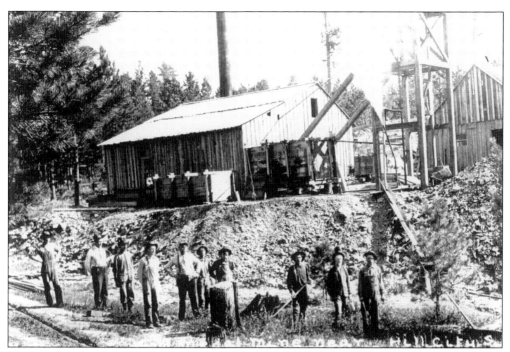

Miners take a break at the Golden Summit Mine (Gold Medal) in Palmer Gulch near Hill City around 1905. The building held the hoisting works. The head frame for the 300-foot vertical shaft is to the right of the building. The mine was developed intermittently from 1878 until 1913. (Photograph courtesy of Robert E. Hayes.)

This *c.* 1885 photograph shows the back of the Franklin Hotel, a two-story building. An open, hand-dug well appears to the left of the unidentified man and the boy riding his shoulder. Notice the ropes in the well where water was hoisted, one bucket at a time. The well serviced both floors. A ramp to the well connects the well to the second floor of the hotel. Each room in the Franklin Hotel was furnished with a porcelain washbasin and pitcher. (Photograph courtesy of Robert Ovnicek.)

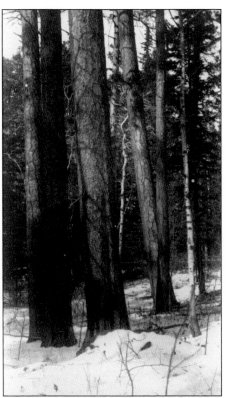

Large ponderosa pine, native to the Black Hills, were cut and fed to the steam boilers, which provided power to the mines. Large timbers were also used for ground support. (Photograph courtesy of the Minnilusa Pioneer Association.)

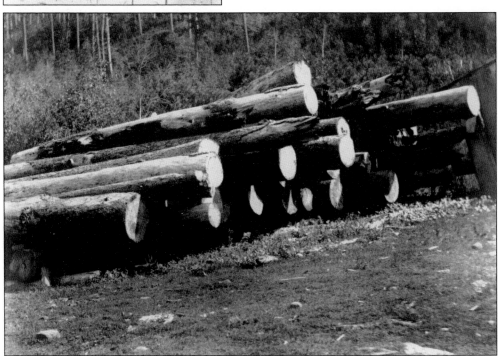

Logs such as these were piled at landings and rolled onto wagons for transport to area sawmills and mines. (Photograph courtesy of the Minnilusa Pioneer Association.)

A lady with a large black umbrella walks along a scenic trail deep in the woods outside Keystone. (Photograph courtesy of the Minnilusa Pioneer Association.)

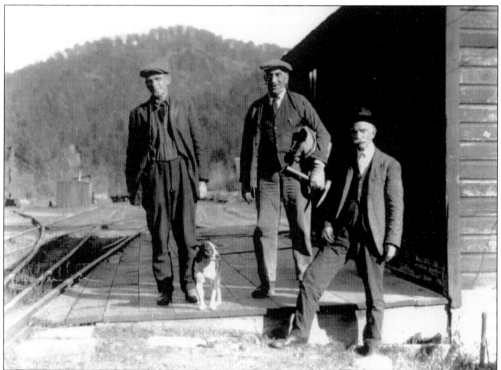

Three mining men gather at the Keystone railway depot in 1924. From left to right, they are John Manion, Dr. A. T. Roos, and David N. Swanzey. Manion owned the Bullion Mine. Dr. Roos, a geologist, successfully advocated for lower freight rates, which helped develop Eastern markets for Keystone-area feldspar. Swanzey was the depot agent. The railway track toward the left of the photograph led to a turntable where locomotives were spun around for their return trip to Hill City. (Photograph courtesy of Robert E. Hayes.)

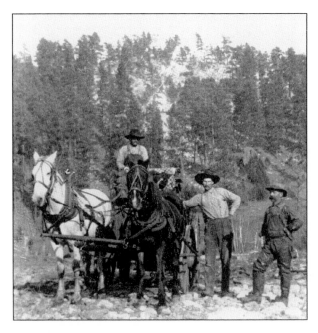

Ed Rhodes, center, is shown with his team of horses in this *c.* 1920 photograph. Rhodes later sold his Hermosa, South Dakota, ranch to Mount Rushmore sculptor Gutzon Borglum. Borglum built a studio at the ranch and resided there between 1928 and 1941, while the mountain carving was in progress. Borglum's grandson, Jim Borglum, now owns and resides on the Borglum ranch. Jim is a sculptor in his own right. (Photograph courtesy of the Halley collection.)

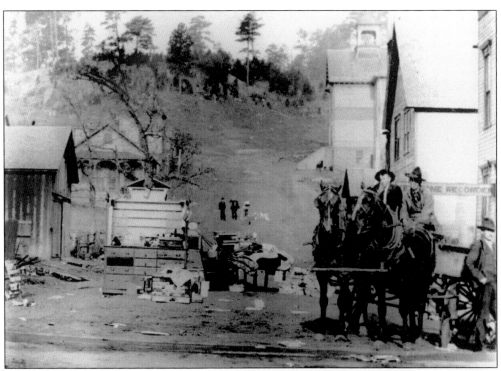

A crew cleans up a mess on Franklin Street following a major fire in 1917. A corner of the Methodist-Episcopal Church can be seen behind the team of horses and wagon. A storefront sign, "The Keystone Recorder," can also be seen behind the wagon. The *Recorder* was Keystone's newspaper of record for many years. Farther up the hill, a corner of the Keystone School is visible. (Photograph courtesy of the Halley collection.)

Early celebrations in Keystone nearly always featured horse racing on Main Street. This photograph depicts a race sometime in the 1920s. (Photograph courtesy of the Halley collection.)

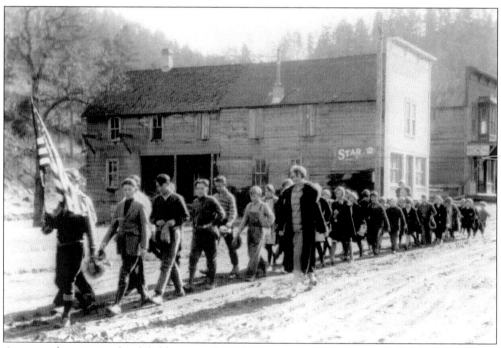

A group of patriotic schoolchildren march Old Glory down Main Street, probably on Armistice Day, November 11, 1918. T. G. Hoy and Company occupied the first store on the left. Tom Hoy and his father-in-law, Andrew Marble, owned and operated the store. On the far right is the Hayes-Hopkins Supply Company, owned and operated by John M. Hayes. (Photograph courtesy of the Halley collection.)

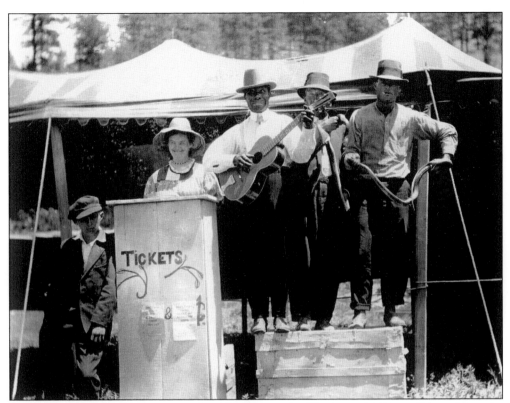

Performers entertain Keystonians in the 1920s during the "Snake and Alligator" show. Note the man on the far right holding a snake. (Photograph courtesy of the Halley collection.)

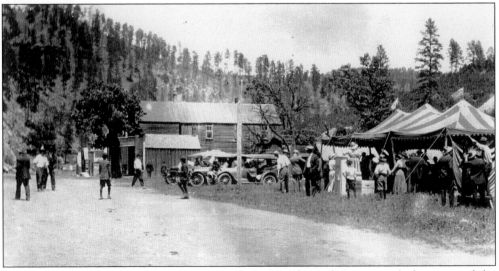

The Snake and Alligator show offered a carnival atmosphere, drawing people from around the region. This photograph, probably from the mid-1920s, shows the one-story office building (center left) originally owned by Charles Patton, likely the last lawyer to keep an office in Keystone. (Photograph courtesy of the Halley collection.)

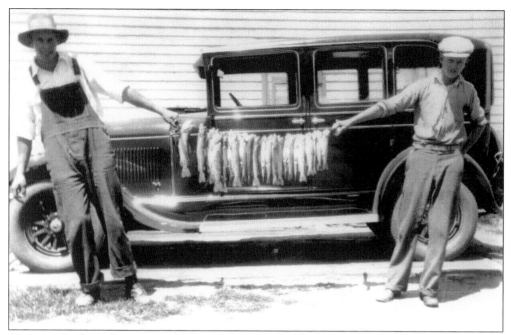

Two men display a fine string of trout, likely caught in the rocky pools of Battle Creek, which winds its serpentine way through Keystone. (Photograph courtesy of the Halley collection.)

This pool, shown in a photograph from about 1920, on upper Grizzly Bear Creek, called "Big Rock," was a favorite natural spa. Another pool, also called "Big Rock," lay below Keystone on Battle Creek. Early families often dammed the creeks in the area to create swimming holes, naming them after area families, including Holmes's Pond and Henry's Pond. (Photograph courtesy of the Halley collection.)

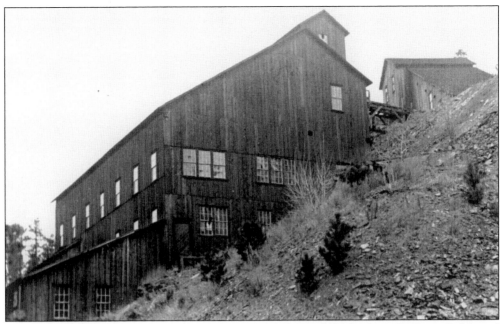

The Bismark Mill, shown here about 1910, was located on a hillside above Buckeye Gulch and above the Buckeye Tunnel. Beginning in 1893, a 450-foot vertical shaft was driven into the earth to access the ores beneath. The mine operated intermittently into the early years of the 20th century. In 1936, a development company leased the property and re-timbered the shaft. Promoters enticed the great heavy-weight boxing champion Jack Dempsey, known as the "Manassa Mauler," to visit the site as a possible investor. (Photograph courtesy of Robert E. Hayes.)

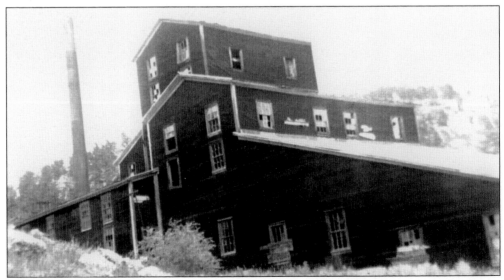

The Spokane Mine and Mill, shown here around 1945, operated intermittently from 1891 to 1940. The property is located approximately 12 miles southwest of Keystone. The mine produced gold, silver, lead, and zinc. The mill was a real museum piece, powered by a steam engine with numerous belts and pulleys mounted on shafts under the floor or the ceiling. Several years ago, the mill was destroyed by fire—possibly an act of arson. (Photograph courtesy of Jessie Sundstrom.)

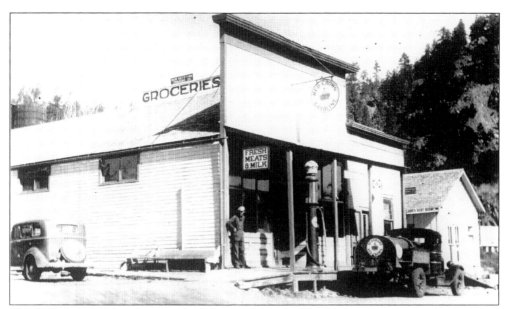

Charlie "Mud" Soliday observes the delivery of Standard Red Crown gasoline to the Keystone Trading Company (KT for short) in the early 1930s. Rollie Marsh of Hill City was probably the deliveryman. The building on the far right was the office of the Battle Creek Power Company, which supplied electric power to Keystone, Mount Rushmore, and the South Dakota State Game Lodge in Custer State Park. Years later, the KT's name was changed to the Halley's Store. (Photograph courtesy of the Halley collection.)

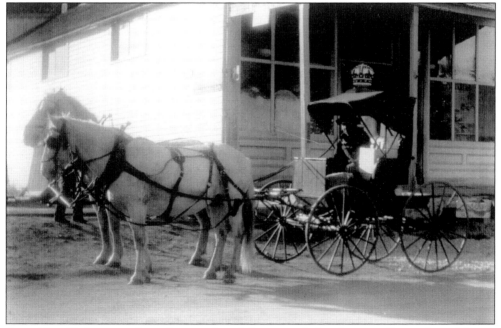

An unidentified man sits for a photograph with his team of white horses pulling a doctor's buggy around 1925. The Keystone Trading Company's Standard Red Crown gasoline pump behind the buggy indicates that the horseless carriage era was well underway. (Photograph courtesy of the Halley collection.)

Supervisors and other dignitaries often rode the Chicago, Burlington and Quincy Railroad in touring cars modified for the rail. This photograph, from about 1918, features an early automobile, possibly a Model T Ford or an early Dodge. (Photograph courtesy of Robert E. Hayes.)

Franklin Street was always a favorite hill for sledding. Children used to place washtubs filled with water on their sleds and dump water, keeping the slope slick and fast. The front of the Methodist-Episcopal Church is in view on the right. The church burned down on Thanksgiving Day in 1921. (Photograph courtesy of Robert E. Hayes.)

Two

THE MOUNT RUSHMORE YEARS
(1925–1941)

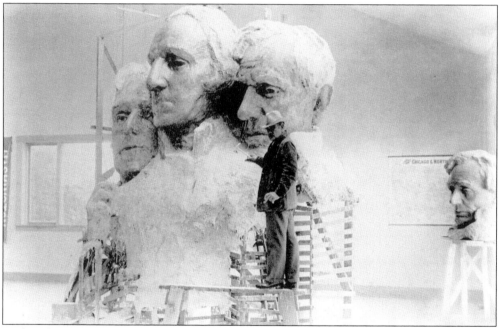

In this photograph, taken sometime prior to 1931, Gutzon Borglum works on one of his early plaster of paris models for Mount Rushmore. The model clearly shows Borglum placing Pres. Thomas Jefferson to the right of Pres. George Washington. The sculpture on the mountain, of course, was completed with Jefferson to Washington's left. In 1934, the bust of Jefferson to Washington's right was blasted off the mountain, a controversial move that set the project back some $10,000 and countless man-hours. Several theories still circulate as to why Jefferson was removed. One theory is that Hugo Villa, an assistant sculptor, excavated too much rock around Jefferson. Another theory states that the granite for the original Jefferson placement contained too many fissures. A third theory is that Borglum overheard a woman tourist complain that "Mr. Borglum would never carve two men snuggled up to each other like that." And so, Borglum, concerned about political correctness, blew Jefferson apart. The fourth theory and, perhaps, the most plausible, is that Borglum did not like his original design. In defense of Villa, he was always against carving Jefferson to the right of Washington. (Photograph courtesy of the Keystone Historical Museum.)

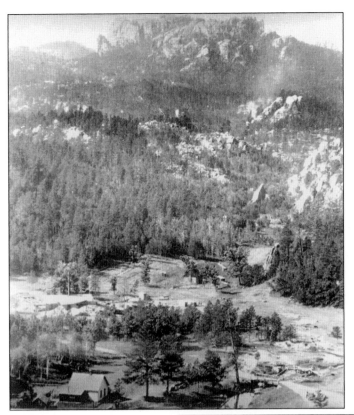

This c. 1925 photograph is titled "Rushmore's Golden Valleys," by Martha Linde. Grizzly Bear Creek can be seen meandering in the foreground. Water flows into the creek from Slaughterhouse Gulch. Over the years, the impressive mountain in the background had several names: Cougar Mountain, Slaughterhouse Mountain, Keystone Cliffs, and, most famously, Mount Rushmore. (Photograph courtesy of Martha Linde.)

In 1885, Charles Rushmore (pictured here) was a New York attorney visiting the Black Hills on behalf of the Harney Peak Tin Mining, Milling, and Manufacturing Company. Rushmore was touring the area with David Swanzey and Bill Challis, two local mining professionals. When Rushmore looked up at a large granite outcrop, he asked what the mountain was called. Challis told Rushmore the mountain was unnamed, then quipped, "From now on, we'll call the damn thing Mount Rushmore." The name stuck. (Photograph courtesy of the Bill Groethe.)

Doane Robinson, pictured here in the early 1920s, was the state historian for South Dakota. Robinson was looking for ideas to entice people to visit the state. Apparently, Robinson flashed on the idea that a sculpture of monumental size could be carved somewhere in the granite core of the mountainous Black Hills. After sculptor Laredo Taft turned Robinson down, the historian wrote Borglum. The rest is history. (Photograph courtesy of the Keystone Historical Museum.)

John Gutzon de la Mothe Borglum was born near Bear Lake, Idaho, on March 25, 1867. Both Charles City and Ovid, Idaho, claim to be Borglum's place of birth. His Danish family emigrated from Denmark in 1864. Gutzon left home at a very young age, studied art in California, and became a student of Auguste Rodin while in Paris. After training abroad, he returned to the United States, where his artwork became quite popular. After 1910, he painted little, instead concentrating on sculpting. His work on Mount Rushmore makes him one of the best-known sculptors in history. Borglum died on March 6, 1941, months before the image of Theodore Roosevelt was completed. (Photograph courtesy of the Keystone Historical Museum.)

This photograph, dated 1923, shows a close-up of Mount Rushmore before carving began in 1927. (Photograph courtesy of the Minnilusa Pioneer Association.)

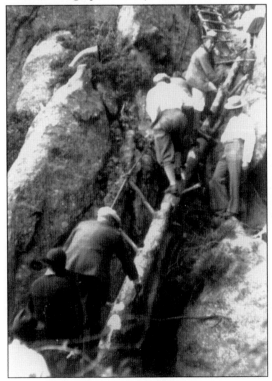

The ascent to the top of Mount Rushmore was quite difficult and dangerous in 1925. This scene is on the backside of the mountain. Note the first lift on the ladder is nothing more than a timbered ponderosa pine trimmed back to create limbed "steps" that acted as ladder rungs. Gutzon Borglum is leading the group. (Photograph courtesy of the Halley collection.)

Borglum quickly established himself as a notable "resident" of Keystone. The building shown in this 1925 photograph is the T. G. Hoy and Company Pharmacy. Pictured from left to right are Maj. Jesse T. Tucker, Lincoln Borglum, Gutzon Borglum, and Ray Sanders. Tucker was Borglum's superintendent at Stone Mountain, Georgia, a huge rock sculpture Borglum was affiliated with during its early development. Tucker served Borglum as superintendent of Mount Rushmore for the first year of that project's development. (Photograph courtesy of the National Park Service, Mount Rushmore National Memorial, Rev. Carl Loocke, September 1925, MORU 3697.)

A group of Keystonians pose atop Mount Rushmore in 1925, before the actual carving began. From left to right, they are Harold Swanzey, Ted Hesnard, Reggie Perkins, Delbert Perkins, Edwald Hayes, Gladys Roberts, George Hesnard, Ellen Hayes, Myrtle Hildebrand, Josephine Hesnard, Francis Miner, and Nettie Schermer. (Photograph courtesy of Robert E. Hayes.)

This *c.* 1927 photograph shows what is likely the first plaster of paris model Borglum formed for the memorial on Mount Rushmore. Note that this model does not include Theodore Roosevelt. After talks with Pres. Calvin Coolidge, Borglum began to model the memorial with Roosevelt as the fourth image. Also note that Borglum considered carving the presidents from the waist up. Over time, Borglum changed his vision for the images at least nine times. (Photograph courtesy of the Keystone Historical Museum.)

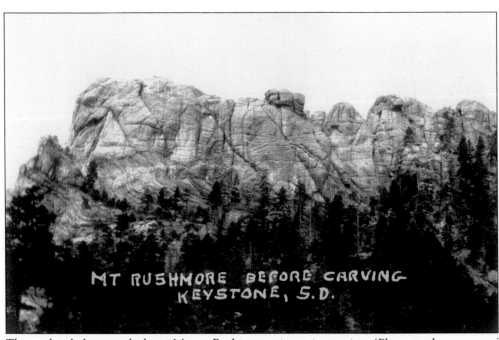

This undated photograph shows Mount Rushmore prior to its carving. (Photograph courtesy of the Keystone Historical Museum.)

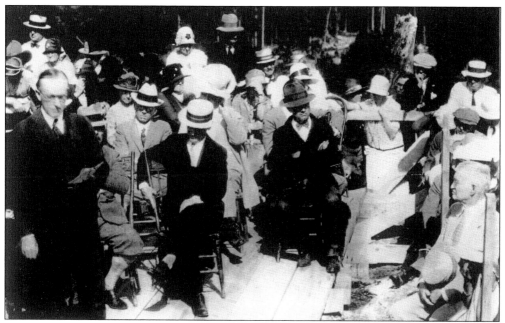

Pres. Calvin Coolidge gave the keynote address at the Mount Rushmore dedication ceremony on August 10, 1927. Coolidge gave Borglum six pieces of drill steel, and the sculptor hustled up the stairway to the mountain. Appearing as small as a fly to the crowd below, Borglum was lowered over the mountainside in a bosun's chair, and he immediately drilled four holes to mark the beginning of the Washington bust. When Borglum returned off the mountain, he handed one drill steel each to Coolidge, South Dakota Senator Peter Norbeck, and Doane Robinson. One other piece of drill steel may have been given to C. C. Gideon, a self-taught engineer who designed the pigtail bridges along the Iron Mountain Road near Mount Rushmore. (Photograph courtesy of the Keystone Historical Museum.)

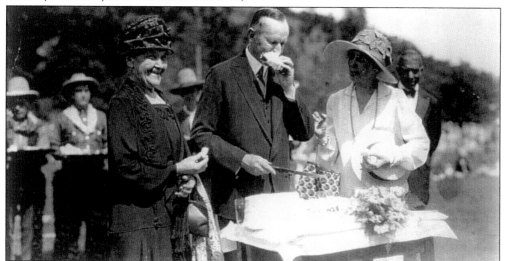

Local residents serve Pres. Calvin Coolidge and First Lady Grace Coolidge cake at the dedication ceremony at Mount Rushmore on August 10, 1927. Shown to the left of the president is Mary Halley of Rapid City, who baked the ceremonial cake. The first lady, in light-colored attire, is shown to the right of the president. (Photograph courtesy of the Halley collection.)

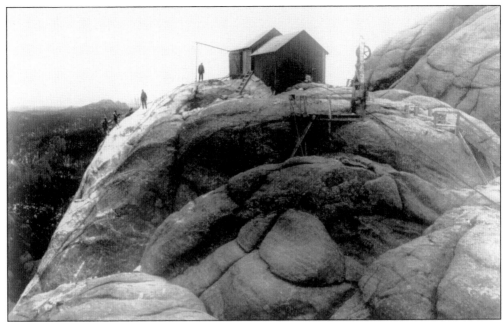

This photograph, taken in the late 1920s, shows the top of the mountain as carving got underway. The two buildings, set above the emerging head of Washington, housed the winches and tool room where the pneumatic tools were repaired. Note the pulley used to hoist the tool bucket up the mountain. (Photograph courtesy of the Keystone Historical Museum.)

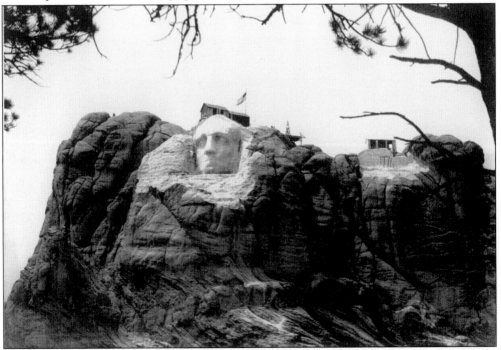

This 1930 photograph shows the image of Washington as if he is peeping out of a porthole. Note the flag waving at the top of the mountain. (Photograph courtesy of the National Park Service, Mount Rushmore National Memorial, Rise Studios, July 4, 1930.)

This *c.* 1930 photograph is a bit of a mystery. A pond appears in the foreground with Mount Rushmore rising in the background. It is unclear how or exactly where this pond formed. (Photograph courtesy of the National Park Service, Mount Rushmore National Memorial, Lincoln Borglum Collection, MORU 3058.)

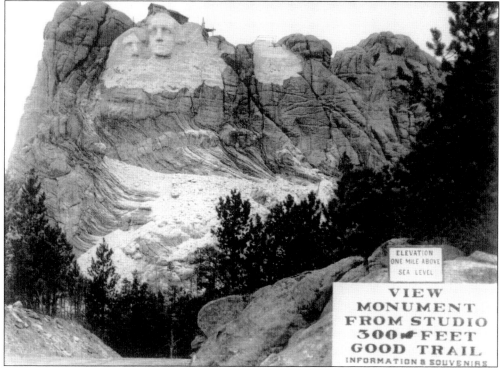

This photograph from 1931 shows the outline of Thomas Jefferson's nose emerging to the right flank of Washington. The visage of Jefferson was later blasted away and permanently placed to the left of Washington. (Photograph courtesy of the Keystone Historical Museum.)

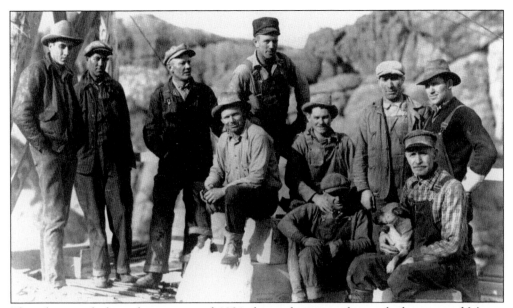

This photograph from the summer of 1931 shows the crew who worked on top of Mount Rushmore that year. Pictured at the very front is Howard "Howdy" Peterson; from left to right are (first row, seated) Alton "Hoot" Leach, James "Jim" Payne Jr., and Charlie "Pop" Cheney with his dog "Boots;" (second row, standing) superintendent Bill Tallman, Alfred "Pop" Berg, Art "Otho" Johnson, Otto "Red" Anderson, Ray Grover, and Jack "Joe Palooka" Payne. Many workers went by their nicknames rather than their birth names. Leach was called "Hoot" because he wore a hat similar to Hoot Gibson, a western movie star. (Photograph courtesy of Robert E. Hayes.)

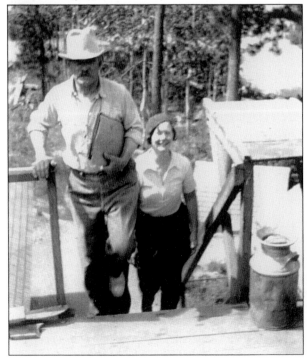

Borglum and Josephine Hesnard climb stairs near the base of Mount Rushmore in this photograph from the early 1930s. A note on the back of the photograph credits Hesnard as the first woman atop Mount Rushmore. (Photograph courtesy of the Hesnard collection.)

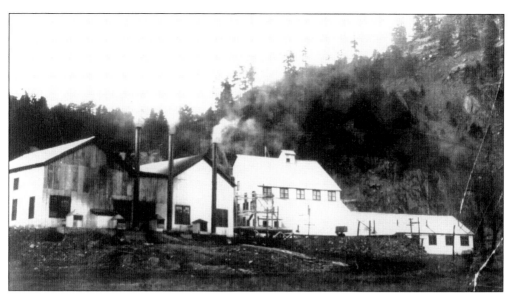

Keystone Consolidated Gold Mines, Incorporated, furnished electrical power to Keystone, Mount Rushmore, and the State Game Lodge in nearby Custer State Park. The power plant was equipped with three six-cylinder, diesel-powered, Fairbanks Morse engines that drove generators. The plant lost two units due to receivership shortly after this photograph was taken in 1928. The Keystone Gold Mill is shown to the right. (Photograph courtesy of Robert E. Hayes.)

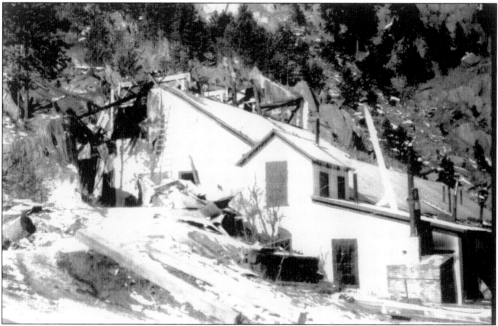

The Keystone Gold Mill was partially destroyed by fire on New Year's Day in 1930. It was later rebuilt in 1938 and operated for almost four years, but was shut down in 1942 due to a wartime order indicating that gold was not essential to the war effort. Almost daily in the 1930s, Keystone boys would play "cops and robbers" in what was left of the mill. When enough boys got together, they would choose sides and play sandlot baseball. Co-author Robert E. Hayes was one of those boys. (Photograph courtesy of the Halley collection.)

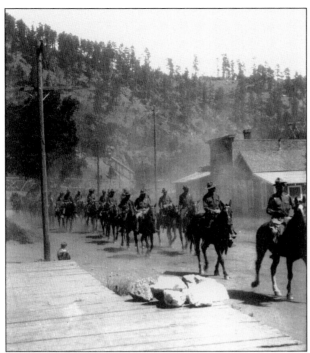

Despite the carving of Mount Rushmore, life went on in Keystone much as before. This photograph from the 1930s shows horse soldiers from Fort Meade, near Sturgis, South Dakota, riding down Main Street. A one-legged blacksmith named Ernest "Pegleg" or "Peggy" Hasse owned the two-story building shown to the right in the photograph. Peggy often complained about having to purchase two shoes when he only needed one. The Vincent and Amelia "Babe" Cordes family rented the house shown to the right of the blacksmith shop. (Photograph courtesy of the Halley collection.)

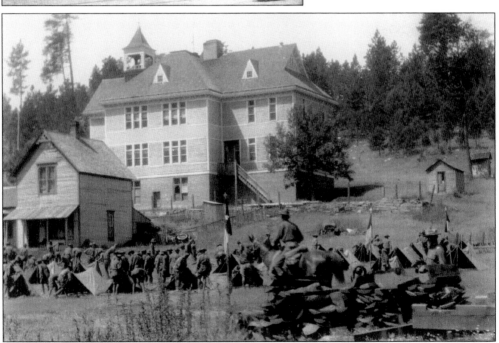

Horse soldiers from Fort Meade bivouac below the Keystone School in this photograph from the 1930s. The Bert "Slick" Andrews family lived for a while in the house shown below the school. The family included seven boys and two girls. Gustav "Bay" and Grace Jurisch lived in the house when they first moved to Keystone from Scenic, South Dakota, in the early 1930s. Bay operated a barbershop for some time in Keystone and was one of the Mount Rushmore workers. (Photograph courtesy of the Halley collection.)

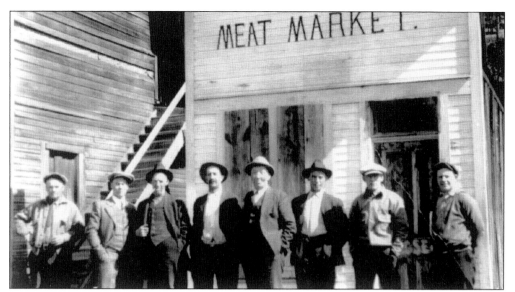

A group of Keystone businessmen, miners, and old-timers pose in front of the Meat Market on the east side of Main Street during the 1920s. David Wasson may have owned the market at the time. Pictured from left to right are John Hayes, A. I. Johnson, Matt Cindel, Jerry Spriggs, I. O. "Mr. K" Kotzebue, Herb Atcheson, Dewey "Duke" Peterson, and Harry "Butch" Wasson. The little building was originally the office of Charles Patton, possibly the one and only attorney ever to practice in Keystone. (Photograph courtesy of Robert E. Hayes.)

1. TEACHERS WILL FILL LAMPS, CLEAN CHIMNEYS AND TRIM WICKS EACH DAY.

2. EACH TEACHER WILL BRING A SCUTTLE OF COAL AND A BUCKET OF WATER FOR THE DAY'S USE.

3. MAKE YOUR PENS CAREFULLY. YOU MAY WHITTLE NIBS FOR THE INDIVIDUAL TASTES OF CHILDREN.

4. MEN TEACHERS MAY TAKE ONE EVENING EACH WEEK FOR COURTING PURPOSES OR TWO EVENINGS A WEEK IF THEY GO TO CHURCH REGULARLY.

5. AFTER TEN HOURS IN SCHOOL, THE TEACHER SHOULD SPEND THE REMAINING TIME READING THE BIBLE OR OTHER GOOD BOOKS.

6. WOMEN TEACHERS WHO MARRY OR ENGAGE IN OTHER UNSEEMLY CONDUCT WILL BE DISMISSED.

7. EVERY TEACHER SHOULD LAY ASIDE FROM HIS PAY A GOODLY SUM FOR HIS DECLINING YEARS SO THAT HE WILL NOT BECOME A BURDEN ON SOCIETY.

8. ANY TEACHER WHO SMOKES, USES LIQUOR IN ANY FORM, FREQUENTS A POOL OR PUBLIC HALL, OR GETS SHAVED IN A BARBER SHOP WILL GIVE GOOD REASON FOR SUSPECTING HIS WORTH, INTENTIONS, INTEGRITY AND HONESTY.

9. THE TEACHER WHO PERFORMS HIS LABORS FAITHFULLY AND WITHOUT FAULT FOR FIVE YEARS WILL BE GIVEN AN INCREASE OF 25 CENTS A WEEK IN HIS PAY PROVIDING THE BOARD OF EDUCATION APPROVES.

Female teachers in Keystone, like their colleagues elsewhere in Dakota Territory and for some time after statehood, were not allowed to be married, per their contract. Presumably, this was to entice eligible women into Keystone for the many men looking for wives. This image depicts the various other rules that Dakota Territory teachers were required to follow in order to maintain their jobs. (Photograph courtesy of Robert E. Hayes.)

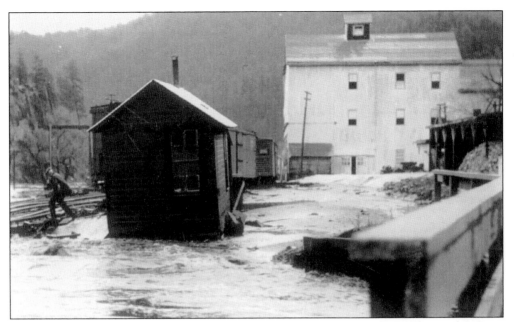

While the Mount Rushmore project helped ease high unemployment rates during the Great Depression, disasters still struck the residents of Keystone. In late May 1933, Grizzly Bear and Battle Creeks overflowed their banks. David Swanzey, depot agent, flees the Chicago, Burlington and Quincy Railroad station in the nick of time with important office records. In the background is the Keystone Consolidated Feldspar Grinding Plant. (Photograph courtesy of the Halley collection.)

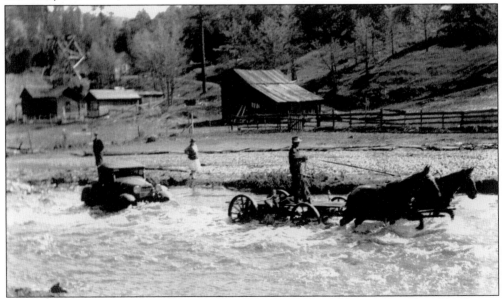

During the 1933 flood, the bridge at the north end of Main Street in Keystone was washed out where it crosses over to Madill Street. Jim Conlin and his team pull a roadster through the flooded Battle Creek across from the present-day Keystone Senior Citizens Center. The Columbia Mine is visible in the upper left of the photograph, as is Isador Roache's home. (Photograph courtesy of the Halley collection.)

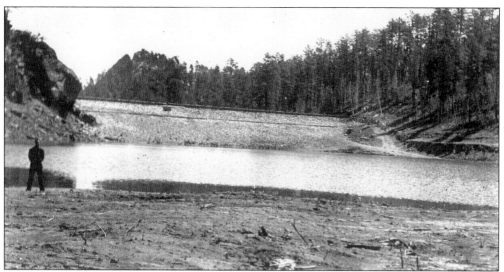

During the 1930s, under the presidency of Franklin D. Roosevelt, the Civilian Conservation Corps—a nationwide program to put young men back to work—was in full swing in the Black Hills. One of their projects was the construction of Horse Thief Dam on Pine Creek five miles west of Mount Rushmore. This photograph shows the dam before water filled in behind it. The young men who built the dam were stationed at Pine Camp, which eventually hugged the shoreline as the water behind the dam rose. (Photograph courtesy of the Halley collection.)

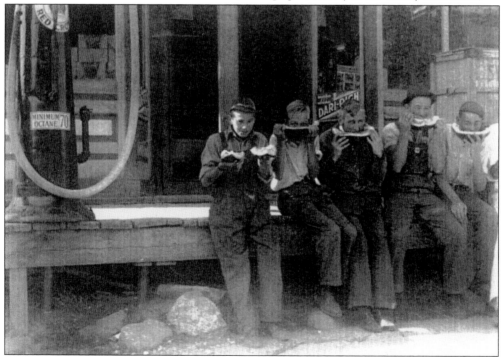

A group of boys and young men enjoy the sticky sweet taste of watermelon outside the Keystone Trading Company (Halley's Store) in the 1930s. Pictured from left to right are Kenneth Brandt, Rex Jatko, Ralph Virtue, Donald "Nick" Clifford, and Wayne Snyder. (Photograph courtesy of the Halley collection.)

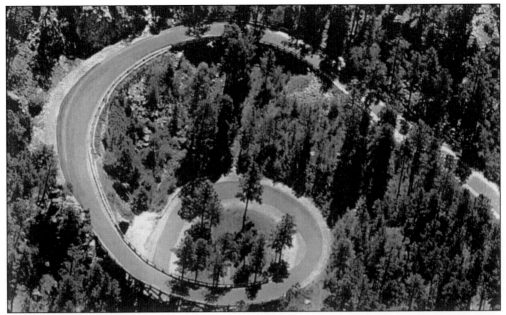

The Iron Mountain Road, replete with pigtail bridges, tunnels, switchbacks, and hairpin curves, was completed in 1933. This undated photograph provides a glimpse of a pigtail bridge not far from Mount Rushmore. Cecil C. Gideon, a self-taught engineer, designed all four of the bridges found along the road. One of South Dakota's best-known politicians, Peter Norbeck, was instrumental in laying out the route and watching the purse strings for the project. Norbeck, a governor and U.S. senator, was a tireless promoter of the Black Hills. (Photograph courtesy of Keystone Area Historical Society.)

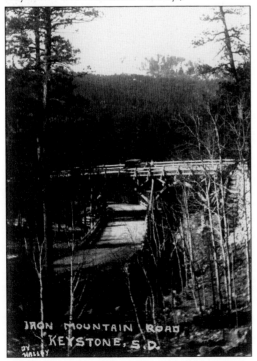

This c. 1935 photograph shows another view of a pigtail bridge along the Iron Mountain Road (U.S. Highway 16A). The pigtail design is rather complex because the bridge crosses a span on a curve and is tilted toward the center of the overall structure. (Photograph courtesy of the Halley collection.)

This c. 1933 photograph from Publishers Photo Service along the Iron Mountain Road depicts how several tunnels along the route frame the images on Mount Rushmore. Note the image of Jefferson emerging to Washington's right. The image of Jefferson was blasted away in 1934 and later carved to Washington's left. Some early tourists without knowledge of Borglum's vision for the mountain wondered if the sculptor was carving the likeness of Martha Washington next to George. (Photograph courtesy of the Keystone Historical Museum.)

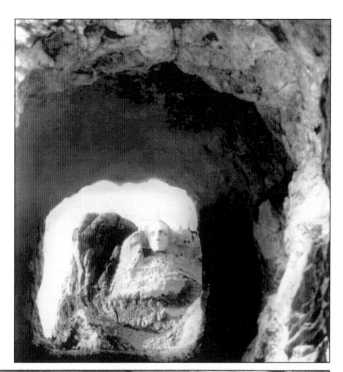

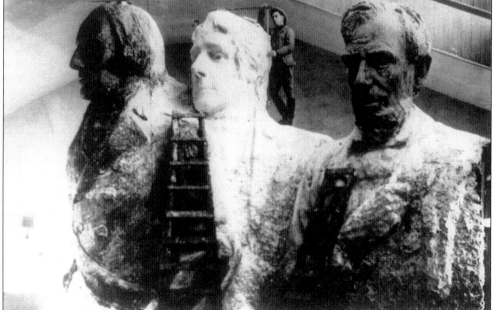

Borglum changed the design of Mount Rushmore at least nine times during the project's 14-year span. In this c. 1934 photograph, Lincoln Borglum, the pointer, takes measurements of Jefferson's bust in this model for the mountain. The average distance from the chin to the head is 60 inches, or five feet. Using a 1 to 12 ratio, Gutzon Borglum's translation of the same chin to head on the mountain was 60 feet. This model was in Borglum's original studio at Mount Rushmore. A new studio was built for the sculptor in 1939 and houses Borglum's original models today. (Photograph courtesy of the Keystone Historical Museum.)

This *c.* 1934 photograph is a very popular shot of Borglum. The sculptor is seated in a harness, or bosun's chair, as he inspects and supervises the work in progress on the mountain. (Photograph courtesy of the Keystone Historical Museum.)

Superintendent John Denison uses a level to measure the exact location to drill blast holes into the mountain in this photograph from the early 1930s. A more sophisticated system was designed and used later on in the mountain carving. (Photograph courtesy of Robert E. Hayes.)

In this photograph from the early 1930s, callboy Jim Payne sits in a harness atop Mount Rushmore. Payne had one-way communication with the winch houses. The workers in the harnesses would signal the callboy by hand signals to go up, down, or stop. The callboy would then give a verbal signal to the winch house with the man's name or the number of the harness. When Borglum was in a harness, he was usually called "Chief" or "Old Man." If there was gossip, the callboy would spread the word all across the mountain. (Photograph courtesy of Robert E. Hayes.)

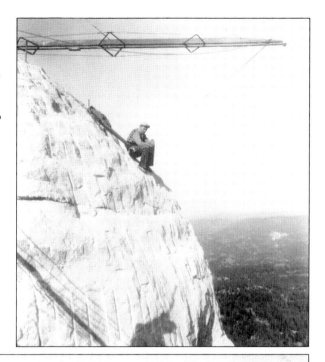

To the Editor of the
Rapid City Journal:

I was one of the unfortunate witnesses of the unnecessary - therefore indecent - exhibits of raw nakedness, flaunted in the face of Rapid City's youth last evening at the Elks Theatre.

A fine looking young blonde woman, with dignity, grace and some commendable art, danced a part obviouslyinvented for the purpose of hiding her naked body, all of which she carried off with commendable grace, bravado and not without motives of beauty, when suddenly, without reason or grace, in vulgar brazonry, she drops her shield and exposes herself in a manner no one ever sees without shock and violation to every code of decency civilisation has created.

What is it that permits our women to make such exhibits of themselves? Can you conceive any man doing likewise? Vulgarize themselves and invite a community's dissent. Can anyone imagine a similar exhibit on Duhamel's sidewalk or in the main long room of the Alex Johnson? Why not? They get us into a theatre and there toss indexency into our unsuspecting face.

There is a strange confusion in the average lay mind that somehow, somewhere this is a product of art. Don't you believe it! It's rotten stage craft; it's gutter conceived and delivered to stiffen the gate receipts. Chicago closed a theatre for less. No artist worthy of the name, no stage manager who cares if he had any reputation would have pulled so poor, so cheap a shock, or been guilty of the gross abuse of everything beautiful in nature and at command of his art as was shown at the Elks last Saturday evening.

Gutzon Borglum

Aug. 11. 1935

This image depicts a letter that Gutzon Borglum wrote to the local daily newspaper complaining about a stage production he watched during an evening at the Elks Theater in Rapid City, across from the Alex Johnson Hotel, which he frequented often. Borglum was known for his bombastic and opinionated views. (Photograph courtesy of the Minnilusa Pioneer Association.)

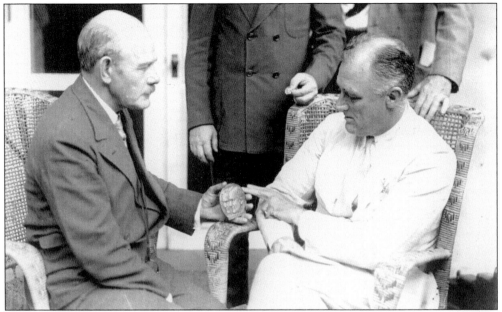

Gutzon Borglum (left) met many times with Pres. Franklin Roosevelt (right) at the White House. Borglum consistently requested additional federal appropriations for the carving of Mount Rushmore. Borglum's reputation, deserved or not, was that of an irascible and stubborn man who was often difficult to work with. More than once, he irritated politicians, including South Dakota leaders, as they worked on behalf of the mountain carving. (Photograph courtesy of Robert E. Hayes.)

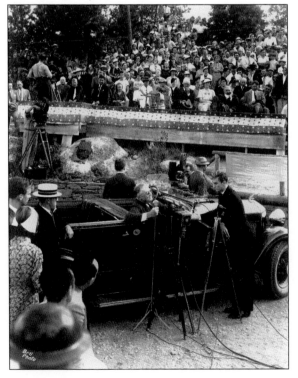

President Roosevelt, seated in the touring car, addresses some 3,000 people at the unveiling of the Thomas Jefferson bust on August 30, 1936. Roosevelt never left the car driven by Paul Bellamy of Rapid City. Among the dignitaries was Senator Peter Norbeck (front row, second from right), bearded and wearing a scarf to conceal the cancer that would take his life less than two months later. Borglum had planned to unveil Jefferson at noon to take advantage of the midday sun, and became outraged when he learned that the president would not arrive until 2:30 p.m. He threatened to go ahead with the program without the president, but finally simmered down and acted the showman he was when the president arrived. (Photograph courtesy of the National Park Service, Mount Rushmore National Memorial, MORU 5349.)

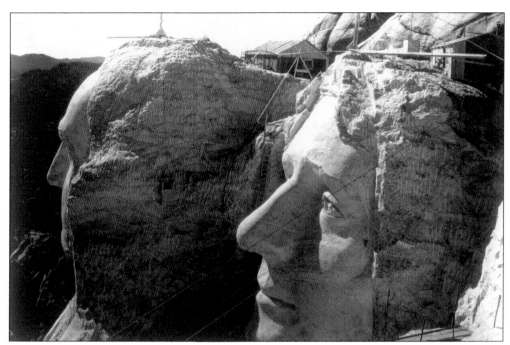

This photograph from the late 1930s shows a bird's-eye view of the profiles of Washington and Jefferson without the appearance of workers or scaffolding. Note the measuring devices on the top of each head. The workers, called pointers, took measurements off of the models in the studio and transferred them in mathematical proportion to the top of the mountain. Pointers would measure the azimuth, an angular measurement, the horizontal distance on the arm, and the vertical distance to a designated point with the use of a plumb bob. The ratio from the studio model to the mountain was 1 to 12, or one inch to one foot. (Photograph courtesy of the Keystone Historical Museum.)

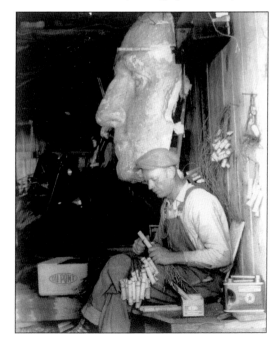

Art Johnson, sometimes called "Baldy Johnson" or "Whiskey Johnson," prepares electrical charges for blasting sometime in the early 1930s. Workers blasted twice daily—at 12:30 p.m. when the men were hoisted up the mountain for lunch, and at 3:50 p.m. when one load of men were hoisted down at quitting time. (The others went down the mountain's stairway.) The mask behind Johnson was taken atop the mountain as a reference tool. Johnson served for a time as a foreman, but was a short-timer in that position. Most foremen were short-timers given Borglum's temper. (Photograph courtesy of Robert E. Hayes.)

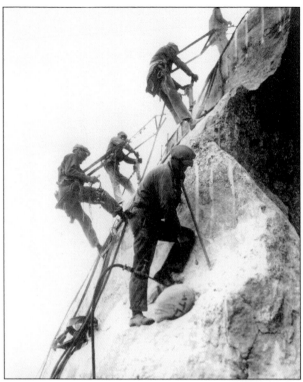

Four workers, seen here around 1935, drill blast holes while suspended in bosun chairs while a fifth man, out of his harness, stands on a ledge, apparently prying at a rock. He may also be cleaning out a blast hole with a blowpipe. If he had slipped, he might easily have died, since he does not appear to be wearing a safety harness. There were no fatalities on the mountain during the carving years. (Photograph courtesy of Robert E. Hayes.)

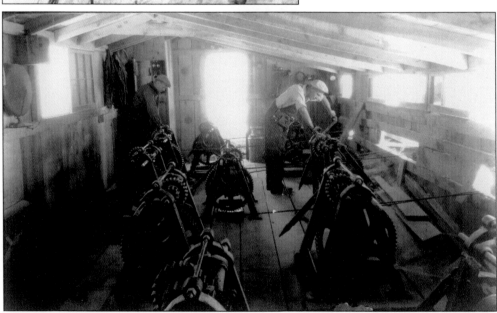

This photograph from the early 1930s shows the interior of the winch house and a series of winches lined up in a row. Jack Payne (on the right) works a winch, which were all hand-operated. Each cable or "wire rope" was three-eighths of an inch in diameter. The other winch man is Ed Young. Borglum's secretary once misspelled a written notice that stated a "wench" should always be made available for the exclusive use of Borglum. Was the secretary simply playing a joke on the boss? (Photograph courtesy of Robert E. Hayes.)

Carver Merle Peterson, drilling honeycomb holes, is suspended in a cage by two separate winches around 1936. The last 10 percent of the rock around a presidential image was removed by this method because blasting was too unpredictable and could deface the surface rock. Holes were drilled on about three-inch centers, and a block defined on about an 18-inch square using a broaching tool that cut between the holes. The honeycomb pattern weakened the rock and a section would be pried off with a chisel and hammer. (Photograph courtesy of Robert E. Hayes.)

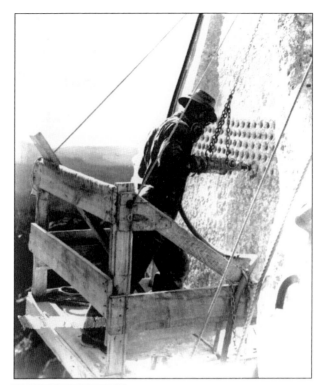

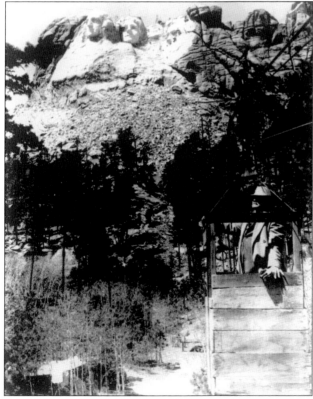

Gutzon Borglum, seen here around 1936, is just leaving the bottom landing to inspect the carving. A three-eighths-inch pull cable was fastened to each end of the conveyance and over a sheave wheel on top, which literally pulled the cage to the top of the mountain in about five minutes. The return trip took about a minute. Borglum would often signal with his hat to stop the cage so he could observe the work. (Photograph courtesy of Robert E. Hayes.)

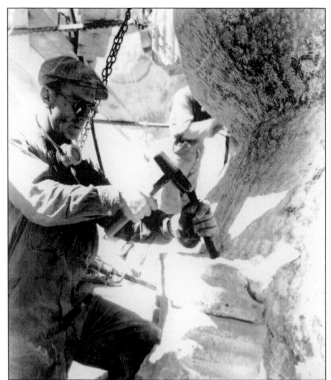

Carver Otto "Red" Anderson chisels out a piece of honeycombed rock sometime in the 1930s. This may be on the lip of one of the presidents. (Photograph courtesy of Robert E. Hayes.)

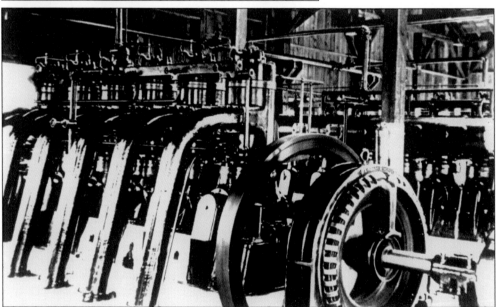

This photograph, taken sometime in the early 1930s, shows the power plant operated by the Battle Creek Power Company (formerly the Keystone Consolidated Mines Incorporated), which supplied electric power for many years to Keystone, the State Game Lodge in Custer State Park, and Mount Rushmore. The plant originally included three six-cylinder diesel engines driving the generators. The Chicago, Burlington and Quincy Railroad delivered the diesel fuel to run the engine. (Photograph courtesy of Robert E. Hayes.)

Sometime in the 1930s, Jay Shepard treats his daughter Inez to a trip to the top of Mount Rushmore. Jay was a winch man for many years. In the photograph, he shows Inez how he lowered workmen over the side of the mountain in a bosun's chair. (Photograph courtesy of the Shepard family.)

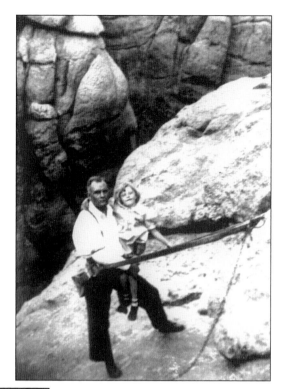

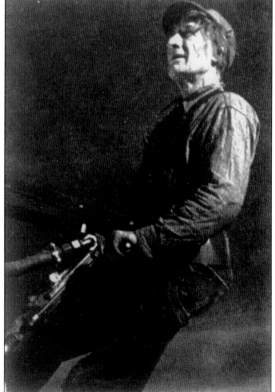

Ray Grover worked nine seasons (nine years) for Gutzon Borglum. During the early years, Grover worked as a driller, as represented by the photograph, taken sometime in the 1930s. Grover was older than most of his fellow workers, and during the latter years he worked as a winch man, which was not as strenuous as handling a jackhammer drill. (Photograph courtesy of Lorraine (Judson) Griffin.)

Edwald "Ed" Hayes loads drill steel into the cable car in this photograph, taken sometime during the 1930s. Hayes operated the cable car for the last seven years of the Mount Rushmore project. Co-author Robert E. Hayes is Ed Hayes's son. (Photograph courtesy of Robert E. Hayes.)

John Nickels sharpens drill steels in this photograph from the 1930s. Some 300 to 500 drill steels were processed each working day. The drill steel is heated to red-hot temperature, and a four-cornered bit is formed on the end of the steel by a set of dies in the pneumatic sharpener. The steel is heated once more and quenched in oil to temper the steel to the correct hardness. Rushmore granite was very hard and abrasive and a bit would not drill many holes before it had to be re-sharpened. A tungsten-carbide insert bit came along sometime after the carving of Mount Rushmore. (Photograph courtesy of the Halley collection.)

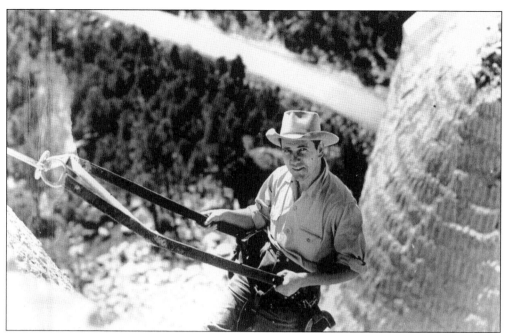

Lincoln Borglum, safely strapped in a bosun's chair, makes a routine inspection of workers' progress on Mount Rushmore in 1937. James Lincoln Borglum, the only son of Gutzon and Mary Borglum, was only 12 when he and his father first came to South Dakota. Lincoln was a volunteer worker for many years at Mount Rushmore and became the fourth and last superintendent in charge of the carving in 1936. (Photograph courtesy of the Keystone Historical Museum.)

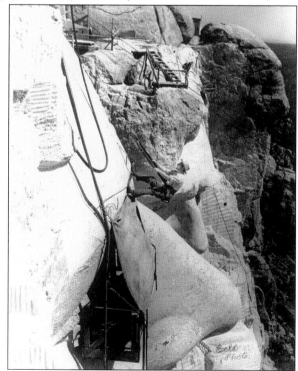

Gutzon Borglum's son Lincoln (center of the photograph on Jefferson's nose) is seen in a bosun chair during the carving of Mount Rushmore, probably in the late 1930s. The noses of Jefferson (foreground) and Lincoln (center) can be seen in the photograph. (Photograph courtesy of the Minnilusa Pioneer Association.)

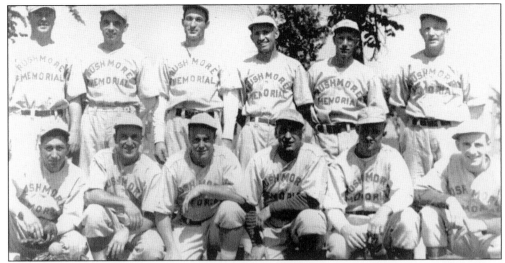

Given the long-standing popularity of baseball in Keystone, Mount Rushmore sponsored its own team. This team is from either 1939 or 1940. From left to right are (first row) Leo Valdez, Frank "Casey" Jones, Glenn Jones, Howard "Howdy" Peterson, Donald "Nick" Clifford, and Ted Crawford; (second row): Bob McNally, Mickey McGaa, Al Johnson, Merle Peterson, Orville Worman, and Otto "Red" Anderson. Not pictured is Edwald Hayes, the umpire and treasurer. (Photograph courtesy of the Keystone Historical Society.)

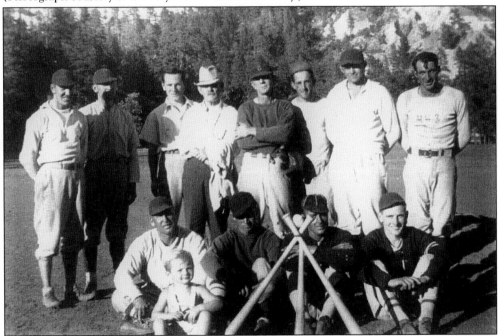

Keystone continued to sport baseball teams until the World War II era. This 1938 team included, from left to right, (first row) Howdy Peterson, Nick Clifford, Glenn Jones, and Ted Crawford; (second row): Casey Jones, Merle Peterson, Lincoln Borglum, Gutzon Borglum, Red Anderson, Earl Conklin, Frank Hughes, and Al Johnson. The boy in the front is Frank Hughes Jr. The team played their home games on a field where the National Presidents Wax Museum is now located. (Photograph courtesy of the Donald Clifford collection.)

This photograph from the late 1930s shows the work as it progressed on the bust of Abraham Lincoln. Gutzon Borglum hangs in a harness below Lincoln's right eye. Note the dangling air hoses. The ladder shown must be at least 60 feet in length and certainly would not meet OSHA (Occupational Safety and Health Administration) standards today. (Photograph courtesy of the Keystone Historical Society.)

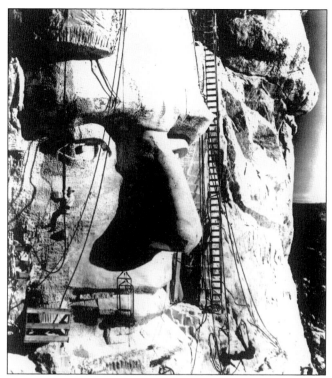

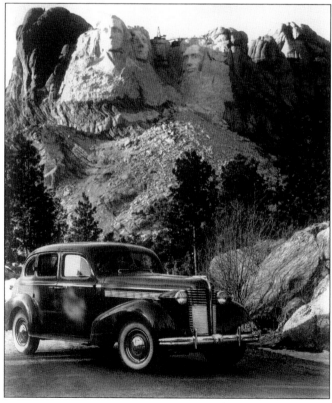

This 1937 Buick must be hot off the production line, since the bust of Lincoln (far right on the mountain) has been just completed. Work at the time of the photograph was beginning on the bust of Theodore Roosevelt. (Photograph courtesy of Robert E. Hayes.)

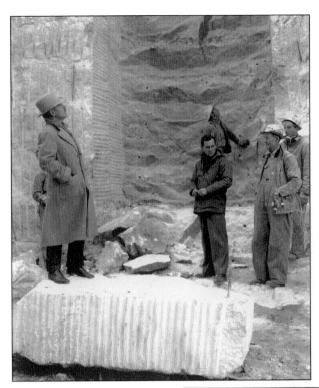

Gutzon Borglum, seen here around 1938, inspects work at the Hall of Records, located on Mount Rushmore but not visible to the public. Borglum had a dream of opening a room 80 feet by 100 feet inside a mass of granite behind the presidential faces. The room was to store historical records and busts of important figures. His dream was never fully realized. Pictured from left to right are Gutzon Borglum, Lincoln Borglum, and a couple of unidentified workers. (Photograph courtesy of the National Park Service, Mount Rushmore National Memorial, Lincoln Borglum Collection, MORU 3409.)

This photograph of the Hall of Records, also taken in 1938, shows workers setting up columns, which are held in place by screw jacks. Pneumatic drills are mounted on the columns. In mines and tunnels, these drills are called "drifters." One man is identifiable—Basil Canfield, who faces the camera and is not covered in dust, unlike the other men. Canfield was the compressor engineer. Canfield had many years of underground mining experience and was called for consultation on how to set up the columns and arms to mount the drifter drills. (Photograph courtesy of Robert E. Hayes.)

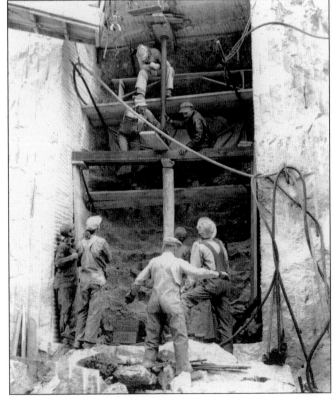

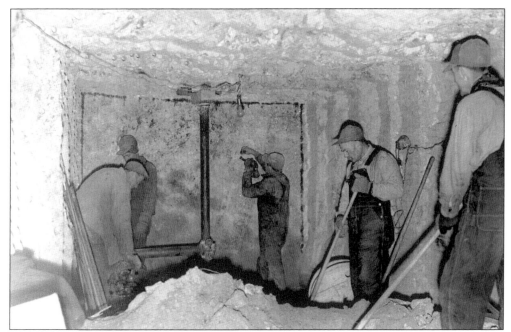

Workmen clean up broken rock inside the Hall of Records around 1938. Note the column in place with screw jacks to mount the drills. (Photograph courtesy of the National Park Service, Mount Rushmore National Memorial, Lincoln Borglum Collection, MORU 3082.)

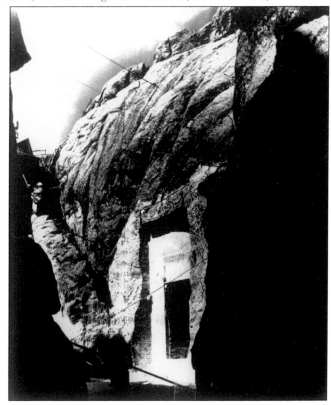

This c. 1938 photograph provides a glimpse of the entryway to the Hall of Records. Note the mass of granite that would have been hollowed out to create an 80-foot by 100-foot room, if the project would have been completed. The façade would have been 60 feet in height. (Photograph courtesy of Robert E. Hayes.)

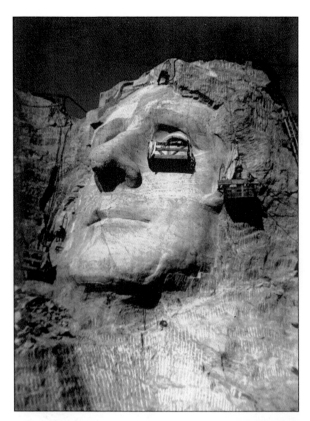

Zooming in on the cage under Jefferson's left eye would reveal Joe Bruner working the rock around 1939. A pocket of almost pure feldspar, which could not be carved, appeared on the upper lip of Jefferson during the sculpting. Bruner and Otto Anderson carefully cut away the feldspar, retrieved a piece of granite from the spoil pile, shaped it, and installed it into the cavity left by removal of the feldspar. Pins and molten sulfur, which acts like glue, kept the granite in place. (Photograph courtesy of Edith (Bruner) Nettleton.)

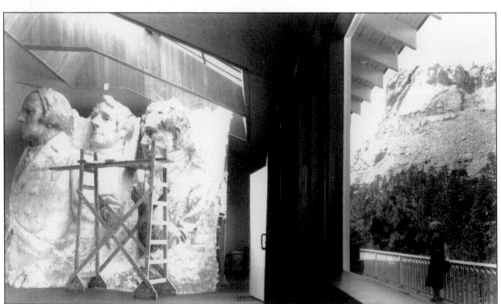

The final design on the mountain is apparent in the upper right corner of this c. 1939 photograph. Note how different the mountain carving looks as compared to one of Borglum's plaster of paris models at the left of the photograph. A woman stands on a viewing deck, built onto Borglum's original studio at Mount Rushmore. (Photograph courtesy of Robert E. Hayes.)

Rushmore workers Joe Bruner (left) and Gus Shramm pose for a photograph around 1939. Bruner holds a drill steel and bits in his hand. Note that a drill weighs about 45 pounds and he is not holding a drill so casually. (Photograph courtesy of Edith (Bruner) Nettleton.)

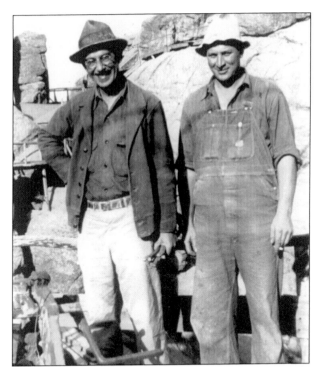

Joe Bruner (right) stands for another photograph in front of Borglum's studio, around 1939, with Frank Skells, the office manager at Mount Rushmore from 1938 to 1941. Bruner was a carver on the mountain from 1938 until the final day of carving—October 31, 1941. Bruner came to America from Alsace-Lorraine—on the border between France and Germany—and raised a family in Bloomington, Illinois. Bruner was a stonecutter in the quarries of Indiana, worked for Borglum in Marietta, Ohio, and eventually came to Mount Rushmore as a carver. (Photograph courtesy of Edith (Bruner) Nettleton.)

A group from the bunkhouse/boardinghouse at Mount Rushmore poses for a snapshot around 1939. The boy in front is Allen Bruner, son of Rushmore worker Joe Bruner. A visitor to the bunkhouse could purchase a family-style meal and homemade ice cream for 35¢. (Photograph courtesy of Edith (Bruner) Nettleton.)

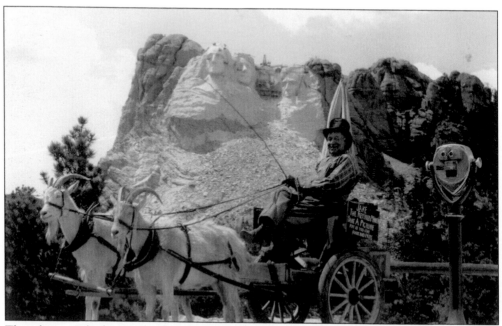

This photograph, from around 1940, shows "Jake" (last name unrecorded) and his goat team at Mount Rushmore. Jake brought his team of goats to Keystone from nearby Custer. Note that commercial binoculars (far right) have been installed for tourists to gain an up-close view of the memorial. The cost to use the binoculars was 10¢. (Photograph courtesy of Keystone Historical Museum.)

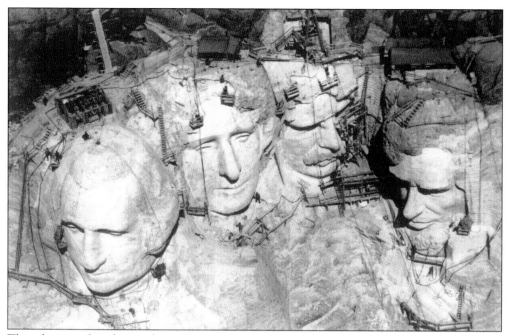

This photograph, taken in late 1940 or 1941, indicates that workers continued to sculpt and hone all of the presidential busts, even Washington, until the final project was completed. (Photograph courtesy of the Keystone Historical Museum.)

This photograph shows the bust of Theodore Roosevelt at or near its dedication on July 2, 1939. The standard procedure was to drape a giant American flag over the face of a president and later remove it during the ceremony. Note that the bust of Roosevelt was dedicated while still not complete. William S. Hart, a popular Western actor from the silent film era gave the main address; however, he spoke longer than scheduled and CBS cut him off, leaving him shouting into the microphone. Hart grew angry and kept shouting. Luela Borglum rushed up to him, threw her arms around the actor and smothered his curses with kisses, helping to thwart a major faux pas. (Photograph courtesy of the National Park Service, Mount Rushmore National Memorial, Russ Apple, MORU 6329.)

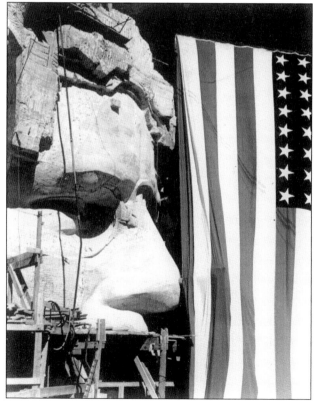

This photograph, taken on October 31, 1941, shows foreman Matthew Reilly and hoist engineer Edwald Hayes formally locking the door to the hoist house after the last run of the cable car to the top of Mount Rushmore. The handshake is blurred because the image was from movie film shot by RKO News. (Photograph courtesy of Robert E. Hayes.)

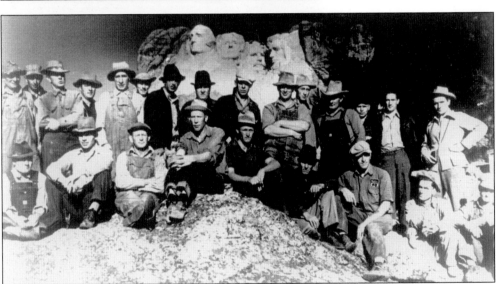

The final crew at Mount Rushmore poses for a photograph in August 1941. Pictured from left to right are (first row) Jay Shepard, Alton "Hoot" Leach, Clyde "Spot" Denton, Pat Bintliff, Ernest "Bill" Reynolds, Gustav "Bay" Jurisch, James "Jim" LaRue, Frank Maxwell, and John Raga; (second row) Orwell Peterson, Ernest Raga, Otto "Red" Anderson, Matthew "Matt" Reilly, Ray Grover, Norman "Happy" or "Hap" Anderson, Joseph "Joe" Bruner, Edwald "Ed" Hayes, Marion "Mony" Watson, Gustav "Gus" Schramm, Earl Oaks, Robert "Bob" Himebaugh, Basil "Bake" Canfield, Robert "Bob" Christon, and Lincoln Borglum. (Photograph courtesy of Robert E. Hayes.)

Three

THE STRATOBOWL
LAUNCHES THE
SPACE INDUSTRY
(1934–1935)

When the National Geographical Society announced it wanted to launch a manned balloon to the limits of the atmosphere never before reached, Rapid City promoters took notice. By 1934, the society selected a site just outside Rapid City in a natural limestone "bowl" that could protect the balloon from winds during the critical inflation period. The site, soon called the Stratobowl, was a major springboard for America's future space-exploration program. Explorer I was launched with three men aboard on July 28, 1934. On November 11, 1935, Explorer II was launched with two men aboard and ascended to a record 72,385 feet (13.7 miles). This photograph shows a number of people camping atop the Stratobowl rim as witnesses to one of the Stratobowl flights. (Photograph courtesy of the Minnilusa Pioneer Association.)

In August 2002, Ed Yost and a few associates formed the Balloon Historical Society to bring public attention to historic U.S. stratospheric balloon flights. Yost and his group placed these monuments to the Stratobowl at the Stratobowl site, with dedication ceremonies on July 28, 2004, the 70th anniversary of the Explorer I flight. The monuments tell the story of the area's natural geological formation and of man's first steps toward the stars. (Photograph courtesy of John S. Craparo.)

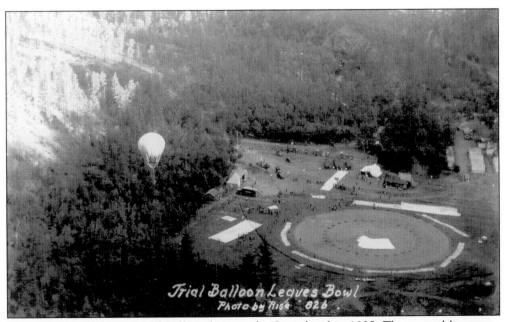

This photograph shows a trial balloon leaving the Stratobowl in 1935. The natural limestone walls have been eroding for millions of years. An ancient river cut out the many layers of limestone in the area to form the three-sided bowl. Today, Spring Creek flows to the west of the Stratobowl. (Photograph courtesy of the Minnilusa Pioneer Association.)

Explorer I readies for take-off from the Stratobowl on July 28, 1934. (Photograph courtesy of the Minnilusa Pioneer Association.)

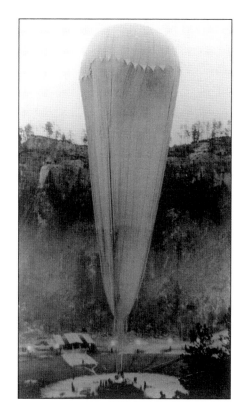

Ed Yost, a hot-air balloon inventor and innovator and president of the Balloon Historical Society, speaks to approximately 100 people at a dedication ceremony at the Stratobowl on July 28, 2004, the 100th anniversary of the flight of Expolorer I. Yost hopes that someday the Stratobowl will be developed into a more visible and viable public history attraction, with improved roads to the site, improved interpretive signing, and a museum dedicated to the important role the Stratobowl played in space exploration. (Photograph courtesy of John S. Craparo.)

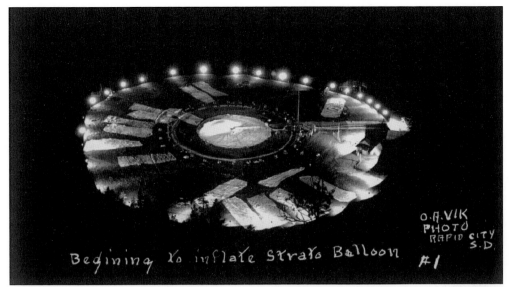

Beginning to inflate Strato Balloon

O.A.VIK
PHOTO
RAPID CITY
S.D.
#1

Hundreds of spectators watched from the rim of the Stratobowl as Explorer I was unfolded and spread across the floor of the bowl on the afternoon of July 27, 1934. Troops from Fort Meade, a cavalry post near Sturgis, South Dakota, assisted in the project. As darkness fell, crews began to pump three million cubic feet of hydrogen gas into the balloon, which covered more than two acres inside the bowl. (Photograph by O. A. Vik.)

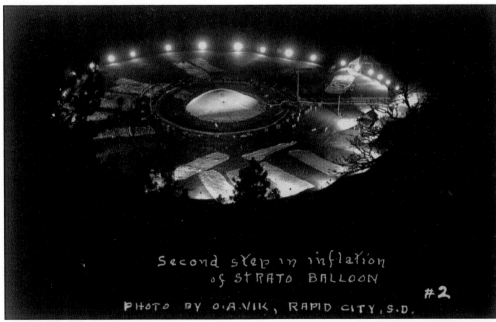

Second step in inflation
of STRATO BALLOON

#2

PHOTO BY O·A·VIK, RAPID CITY, S.D.

To inflate Explorer I, the South Dakota National Guard hauled in 1,500 cylinders of hydrogen gas. Spectators would later say that the balloon looked like the head of a mushroom as it was inflated. Charlie Lyon of NBC broadcast the activity from "ringside." Goodyear-Zeppelin used shirt-weight cotton covered with rubber to build the balloon. Dow Chemical built the gondola, which was constructed from a very strong and light magnesium alloy. (Photograph by O. A. Vik.)

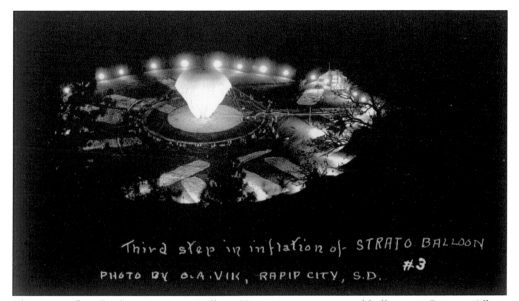

Three men flew Explorer I: Major William Kepner, an experienced balloonist; Captain Albert Stevens; and First Lieutenant Orville Anderson, all with the U.S. Army Air Corps. (Photograph by O. A. Vik.)

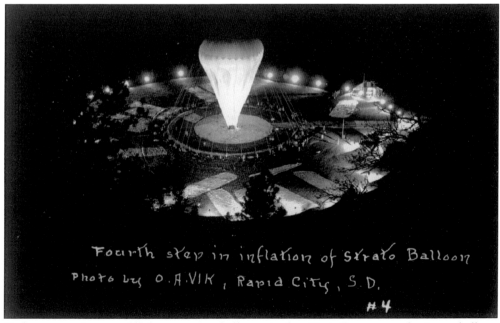

Hydrogen continues to fill the enormous balloon. Author Craig Ryan, an authority on balloon flight, once wrote, "Mankind achieved space in the same way anything is achieved: through lots of small incremental steps." (Photograph by O. A. Vik.)

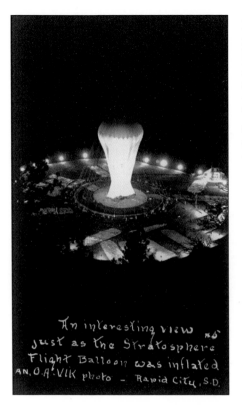

An interesting view as just as the Stratosphere Flight Balloon was inflated AN. O.A. VIK photo — Rapid City, S.D.

In this photograph, the balloon starts to extend more fully skyward. Jim Winkler, a preeminent balloon historian, hails the importance of the Explorer balloon flights: "There is a natural land formation in the Black Hills of South Dakota which served as the Cape Canaveral of its day. The launching of two scientific balloons in 1934 and 1935 commanded almost as much attention and press coverage as the manned space flights of the 1960s." (Photograph by O. A. Vik.)

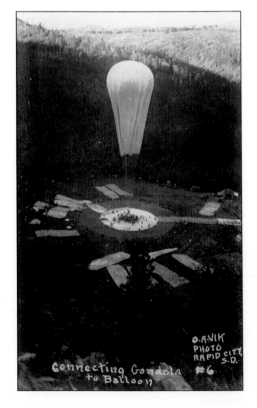

Connecting Gondola #6 to Balloon

O.A.VIK PHOTO RAPID CITY S.D.

At the time, the three-million-cubic-foot Explorer I was the largest balloon ever designed. In the photograph, the balloon appears fully inflated, having reached the height of the Stratobowl rim. The gondola was wheeled out from its protective shed and connected to the balloon. (Photograph by O. A. Vik.)

The inflation took six hours, while attaching various scientific and flight instruments took another three hours. Bags of lead shot were used for ballast. (Photograph by O. A. Vik.)

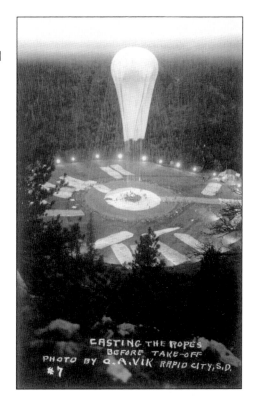

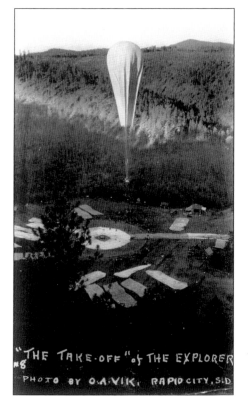

After the three men boarded Explorer I, and after final instrument testing was completed, the balloon's moorings were released at 5: 45 a.m. on July 28, 1934. Lieutenant Anderson remained outside the gondola until the balloon had safely cleared the rim of the Stratobowl. (Photograph by O. A. Vik.)

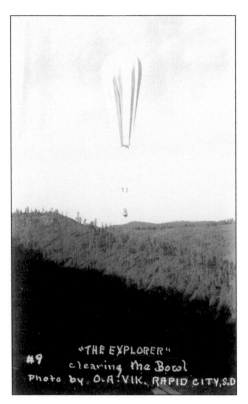

"THE EXPLORER"
clearing the Bowl
Photo by O.A. VIK. RAPID CITY, S.D
#9

Explorer I eventually reached an altitude of 60,613 feet. At the 60,000-foot level, the crew discovered several tears in the lower portion of the balloon, forcing them to descend. Extensive damage occurred at lower altitudes and the crew exited by parachute below the 5,000-foot level. At about 3,000 feet, the hydrogen gas combined with sufficient air to form an explosive mixture, which was detonated by static electricity from flapping fabric. (Photograph by O. A. Vik.)

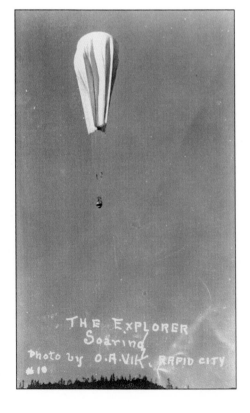

THE EXPLORER
Soaring
Photo by O.A.VIK. RAPID CITY
#10

The three officers parachuted to safety near Holdridge, Nebraska. The instrument capsule inside the gondola was also dropped from the balloon by parachute. Although not all of the goals for the flight were achieved, enough of the scientific instruments and experiments were salvaged to encourage the National Geographic Society and the Army Air Corps to sponsor another stratosphere flight in 1935. (Photograph by O. A. Vik.)

Military cargo vehicles haul supplies to the Stratobowl site in this 1935 photograph. (Photograph courtesy of the Minnilusa Pioneer Association.)

In 1935, Explorer II used a new and larger balloon, which was filled with helium rather than the hydrogen gas used for Explorer I. Helium is heavier than hydrogen, so it took a larger balloon to have the same lifting power as Explorer I. Helium is also less explosive than hydrogen. In this 1935 photograph, a convoy of army trucks from Fort Meade (near Sturgis, South Dakota) carries helium cylinders to the Stratobowl. (Photograph courtesy of the Minnilusa Pioneer Association.)

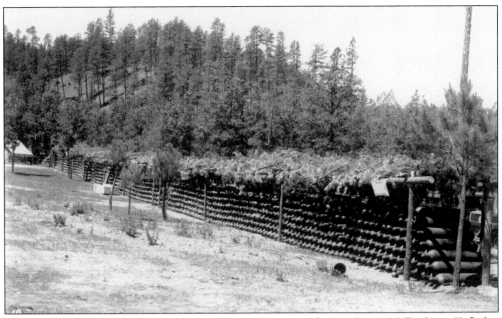

Tanks of helium stacked like cordwood are awaiting use during the 1935 Explorer II flight. (Photograph courtesy of the Minnilusa Pioneer Association.)

The flights from the Stratobowl were covered extensively. The *National Geographic Magazine*, for instance, devoted extensive articles to the Stratobowl and the science of high-altitude flight. In this 1935 photograph, NBC's radio transmitting station was built to bring news of the flights to an interested nation. While television was still a dream unrealized in 1934 and 1935, data collected by the Stratobowl flights did contribute to the satellite age and the growth of worldwide communication systems. (Photograph courtesy of the Minnilusa Pioneer Association.)

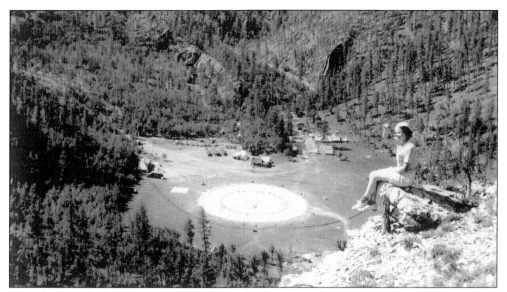

This photograph from 1934 or 1935 shows the launch pad and surrounding support area as seen from the rim of the Stratobowl. Tents and other service buildings surround the launch pad. Civilian Conservations Corpsmen (CCCs) and army soldiers from Fort Meade assisted the National Geographic Society with the flights initiated in the Stratobowl. (Photograph courtesy of Minnilusa Pioneer Association.)

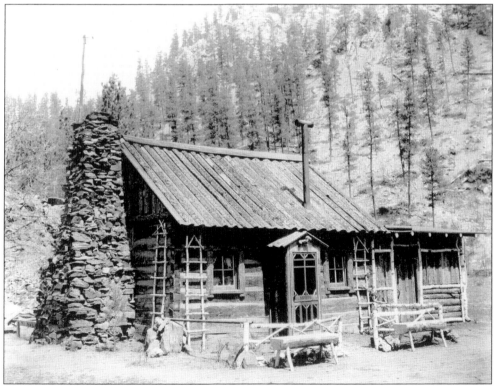

This cabin, in the Stratobowl, was privately owned and may still exist near the site. (Photograph courtesy of the Minnilusa Pioneer Association.)

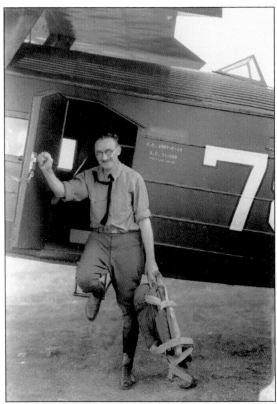

This photograph shows Capt. Albert Stevens climbing aboard an army transport plane. Airplanes followed the flights from the Stratobowl. Explorer II reached a record altitude of 72,385 feet—13.7 miles high. The flight was judged a complete success, gaining scientific data on cosmic rays, ozone distribution, composition of the atmosphere, and information on microorganisms above 36,000 feet. (Photograph courtesy of the Minnilusa Pioneer Association.)

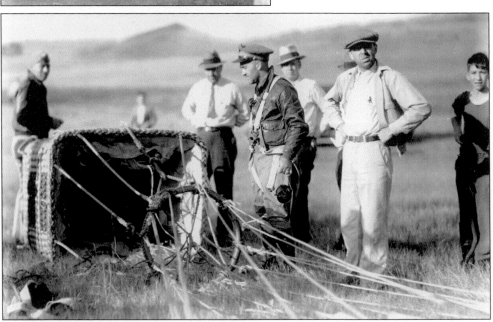

This photograph from 1934 shows men on the ground next to the gondola after a test flight. Lt. Orville Anderson is shown on the far left. Standing in an army flight uniform to the right of the gondola is Maj. William Kepner. The boy at the far right is Craig Gagsteter. (Photograph courtesy of the Minnilusa Pioneer Association.)

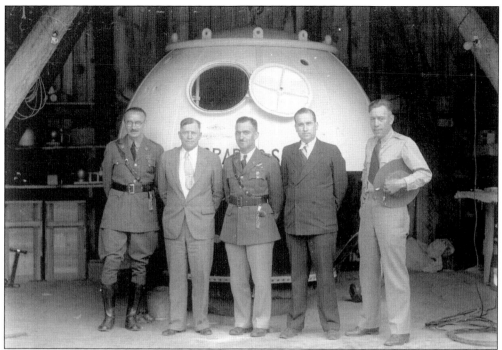

This 1935 photograph shows the gondola of Explorer II and some of the personnel involved in the flight. The gondola was designed for two people, while Explorer I was designed for three people. The two army staff to make the flight on Explorer II were Capt. Orville A. Anderson and Capt. Albert W. Stevens. For the flight, the army officers borrowed two protective football helmets from Rapid City High School. These helmets were on display at the high school for many years. (Photograph courtesy of the Minnilusa Pioneer Association.)

This photograph shows Maj. William Kepner (right) and Capt. Albert Stevens inspecting the instruments inside the gondola. Ed Yost and the Balloon Historical Society would like the gondola from Explorer II to be returned from the Smithsonian Institute in Washington, D.C., and placed in a park and museum at the rim of the Stratobowl. Such a development could educate the public about the importance of the Stratobowl and its role in launching our modern space industry. (Photograph courtesy of Minnilusa Pioneer Association.)

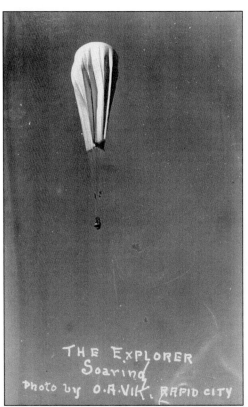

This photograph from 1934 shows the Explorer just after lift-off ascending from the Stratobowl. (Photograph courtesy of the Minnilusa Pioneer Association.)

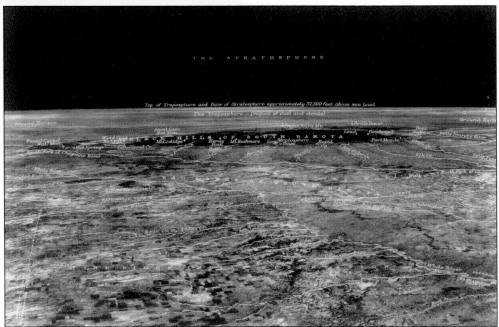

This photograph, taken from Explorer II, shows the earth from more than 37,000 feet. The image looks back to the west and the badlands and Black Hills. (Photograph courtesy of the Minnilusa Pioneer Association.)

Four

THE RISE OF TOURISM
(1925–2005)

While tourism in the Black Hills predates the settlement of Keystone in 1891, Keystone's part in the industry was fairly small until the Mount Rushmore project was underway. By the mid- to late 1920s, shops catering to Mount Rushmore visitors began popping up like mushrooms along Winter Street. U.S. Highway 16 was routed to the presidential monument along Winter Street, making the lane a natural site for tourism-related businesses. This c. 1935 photograph shows Winter Street as viewed toward the north. Mount Aetna, named by Sicilian miners in the 19th century, is seen in the background. The log building on the right is the retail store for Rushmore Pottery. The present-day Ruby House is on the far end of the street. (Photograph courtesy of the John Houser collection.)

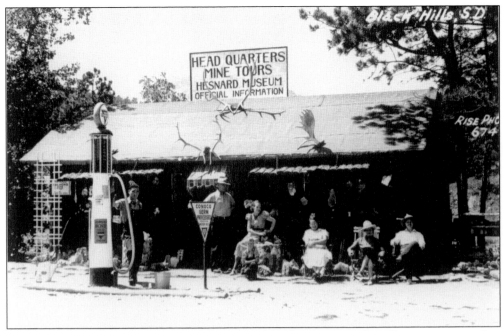

The Hesnard Museum and Mine Tours was one of the first tourism-related businesses opened in Keystone. Note the mica hanging on the shutters. Today, the National Presidents Wax Museum is located on the site. Pictured from left to right are (first row) an unidentified person, Winnie Hesnard, Rose Reddick, and Josephine Hesnard; (second row) Jack McDonald next to the pump, and an unidentified person. Josephine Hesnard and Rose Reddick were the owner-partners. (Photograph courtesy of the Hesnard collection.)

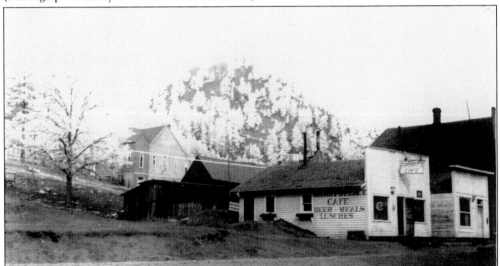

"Old Keystone," or that area of town generally to the east of Winter Street, has also catered to tourists over the years. This photograph from the late 1930s shows Harry's Café. Harry and Marie Biddle owned the café, one of the first restaurants on Main Street in Keystone. Harry's brother, Hubert, built a bar down the street after Prohibition was repealed and called it Hubert's Place. Hubert's Place later became the Rushmore Bar, operated by Mount Rushmore worker Glen Bradford. (Photograph courtesy of Edith (Bruner) Nettleton.)

Gutzon Borglum (right) and Tom Hoy of Keystone stand for a photograph in downtown Keystone sometime in the mid-1930s. As a world-renown artist, Borglum was a well-recognized celebrity and an attraction in and of himself. (Photograph courtesy of the Keystone Historical Museum.)

Hubert Biddle runs his trick horse, Buck, through his routine on the east side of Main Street, around 1934. Biddle was a bootlegger and gambler. After Prohibition was lifted in 1933, he and his wife, Cora Biddle, opened a saloon called Hubert's Place. The couple operated a lunch counter at the back of the bar, which angered Hubert's brother, Harry, who operated Harry's Café nearby. Hubert and Harry once got their bloomers in a knot on Main Street, angrily fighting and hurling coffee cups at each other. (Photograph courtesy of the Hayes collection.)

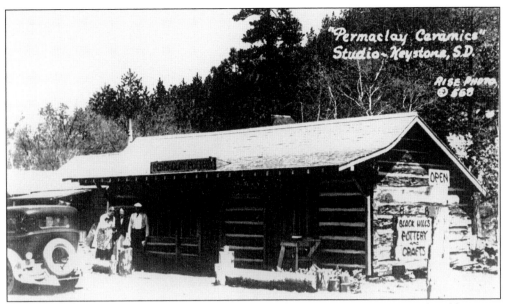

Rushmore Pottery, shown on Winter Street around 1936, was an early tourism-related business. Artists and owners Ivan Houser and Bill Tallman each worked for Gutzon Borglum, either at Mount Rushmore or on other Borglum projects across the country. During the cold months, when work on Mount Rushmore was suspended, Houser and Tallman produced high-quality pottery, which is very collectible today. (Photograph courtesy of the John Houser collection.)

The clay used to make Rushmore Pottery was mined outside Rapid City. Mildred Houser, Ivan's wife, operated the retail store. To prove the quality of their pottery to customers, Mildred would tap on the pottery with a pencil, causing it to ring like a bell. This c. 1936 photograph shows some of the store's fine items. The Housers and Tallmans closed Rushmore Pottery at the beginning of World War II. Bill Tallman was the third superintendent for Borglum at Mount Rushmore. Ivan House was an assistant sculptor and performed most of the work on the models for Borglum. (Photograph courtesy of the John Houser collection.)

This photograph, probably from the late 1930s, shows the last of the White Swan Cabins on Pine Street in Hill City. Pictured from left to right are Margaret Hayes Yates, Mose Hayes, and Ellen Hayes. Mose Hayes owned the White Swan Cabins. Both ladies were nieces of Mose Hayes. It was Mose hayes who coined the expression "Heart of the Hills" for Hill City. (Photograph courtesy of Robert E. Hayes.)

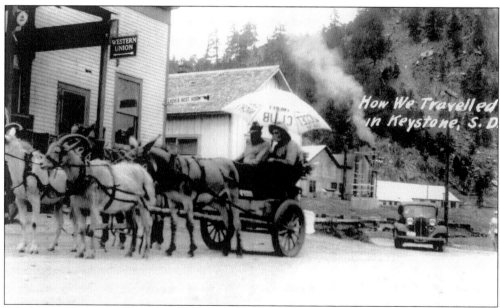

Donkeys and goats pull a wagon in Keystone during a 1940s parade. A man named Jake (last name unrecorded) owned the goats. Dave McVey (right) owned the donkey team. Both men operated separately, giving tourists rides in their carts. Tourists often photographed the men and their teams for tips. (Photograph courtesy of the Halley collection.)

This c. 1933 photograph shows Grizzly Bear Camp, an early tourist-related business. Ed and Ellen Hallsted owned the Grizzly Bear Camp, and they rented "modern cabins" and sold Texaco products and other supplies to visitors. Ed worked at Mount Rushmore for a period of time as a timekeeper and handyman. Today, the Rushmore Borglum Story is located at the site. (Photograph courtesy of Delores (Hallsted) Long.)

This c. 1933 photograph shows the interior of the Grizzly Bear Camp office. Grizzly Bear Creek ran directly beneath the office. From left to right are Ed Hallsted, Ellen Hallsted, and Matilda "Tillie" Pierce—Ellen's mother. The office was stretched across Grizzly Bear Creek and the owners came close to losing the building during the flood of 1933. (Photograph courtesy of Delores (Hallsted) Long.)

In the mid-1870s, the government sent Professor Walter Jenny into the Black Hills to study its geology. Legend has it that Jenny pulled up on a rosebush and found gold clinging to its roots. Supposedly, that episode led to early prospectors who searched for Jenny's rosebush site, and in the process found Rushmore Cave. This *c.* 1935 photograph shows an early entrance to the cave. (Photograph courtesy of Cindy Pullen Esposti.)

Just outside of Keystone near the old town of Hayward lies Rushmore Cave, fully developed by Lester "Si" and Ruth Pullen in the late 1940s. The couple worked hard to draw visitors to their gem inside a mountain. They drove a tunnel from the surface on a decline to the heart of this limestone cave. In this *c.* 1955 photograph, Ruth Pullen looks at stalactites inside the cave. Tours are still provided. (Photograph courtesy of Cindy Pullen Esposti.)

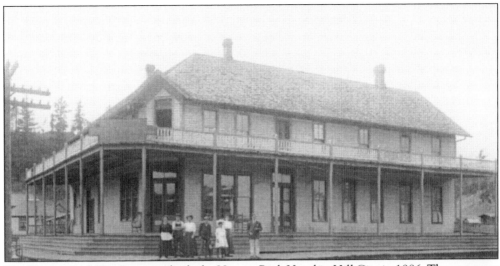

The Harney Peak Tin Company built the Harney Peak Hotel in Hill City in 1886. The company sank millions of dollars into area mining between 1883 and 1893. Except for some mining scars, all that remains of the company is this building—shown in this undated photograph from decades ago. The building still stands and now houses the Alpine Inn in Hill City, a first-class restaurant. (Photograph courtesy of the Alpine Inn.)

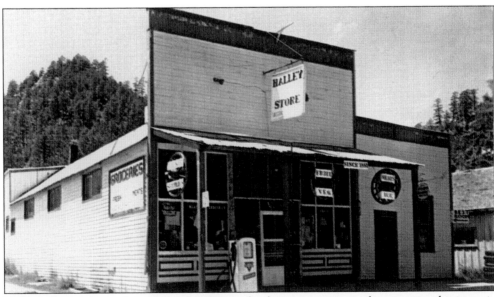

Halley's Store, shown here around 1970, is the longest continuously operating business in Keystone. It was built on Main Street in 1896 and operated as the Keystone Trading Company, a general mercantile store. James Halley III, a banker, purchased the store in 1917. Today, Bob Nelson owns the store and sells antiques, gems, and minerals. (Photograph courtesy of the Halley collection.)

This *c.* 1910 photograph shows the Keystone School, built in 1900 for about $10,000. The school was closed in 1988 and now houses the Keystone Historical Museum, which features memorabilia of the Charles Ingalls family and the James Langer mineral collection, among other items. (Photograph courtesy of the Hesnard collection.)

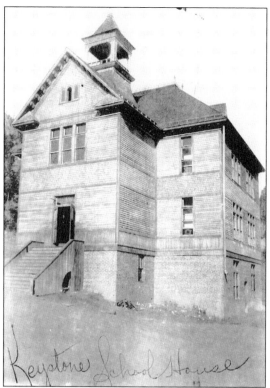

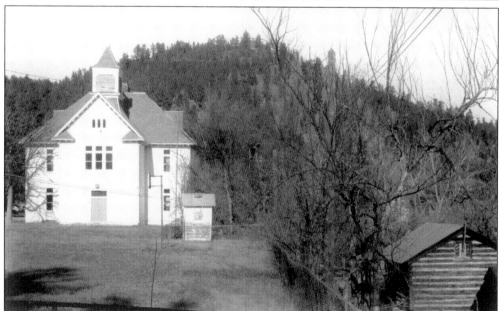

This more recent photograph from around 1990 shows the old Keystone School (left) and a pump house built for a hand-dug well sunk more than 100 feet deep. The school provided five classrooms and a library to accommodate 300 students. The log cabin on the right was the first schoolhouse in Keystone. Mary Wheeluck taught students in this school from 1894 to 1895. (Photograph courtesy of Robert E. Hayes.)

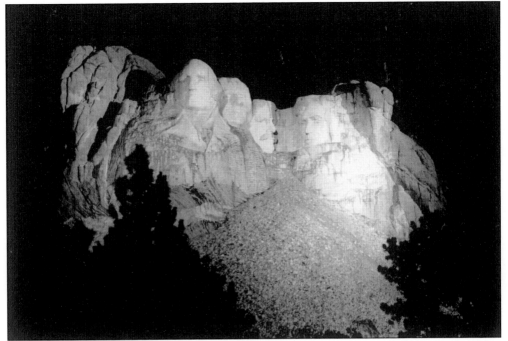

Two banks of lights were originally used to illuminate the faces at Mount Rushmore. The lights were turned on the first day of August 1950. Though the floodlights do illuminate the sculpture as sunlight fades, the lights also reduce the pleasurable effects of natural light and shadows that Borglum strove to create. (Photograph courtesy of Minnilusa Pioneer Association.)

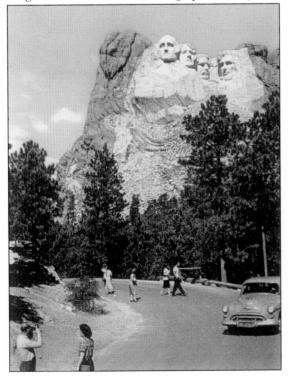

Prior to artificial lighting, one story has it that a visitor arrived to view Mount Rushmore after dark. Angry that he could not see the presidents at night, the visitor woke the park superintendent Estes Suter and told him, "I can't see the faces in the dark!" Suter stepped out of his quarters in his pajamas and looked toward the mountain. His retort to the grumpy visitor was, "I agree with you, sir. I can't see the faces in the dark, either." This photograph is from the 1950s. (Photograph courtesy of Robert E. Hayes.)

Mount Rushmore has been both the topic and setting for everything from poems, to film, to political rhetoric, to music. Ruth Gammon Brown wrote the words and music to this piece published as sheet music in 1948. (Photograph courtesy of the Keystone Historical Museum.)

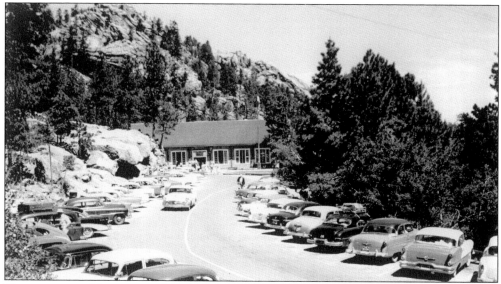

This is a view of the main parking lot at Mount Rushmore in 1950. The lot held 44 vehicles. The sculptor's studio and visitors center are shown in the background. When this lot filled, visitors were directed to five secondary lots farther up the hill. C. C. "Cecil" Gideon designed the sculptor's studio; the same man designed the pigtail bridges on Iron Mountain Drive. (Photograph courtesy of the National Park Service, Mount Rushmore National Memorial, Lincoln Borglum Collection, MORU 3158.)

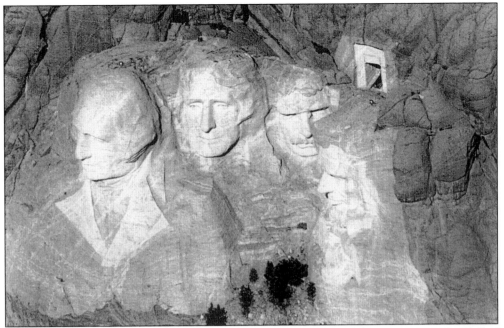

This view taken from the air, around 1960, shows the four faces and the entryway to the Hall of Records. Mount Rushmore is unquestionably the foremost destination of travelers to the Black Hills. (Photograph courtesy of the Keystone Historical Museum.)

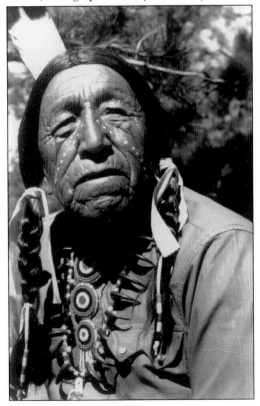

Ben Black Elk, a Lakota (Sioux), was a fixture at Mount Rushmore for many years. He was the son of Nick Black Elk, the great spiritual leader portrayed in the book *Black Elk Speaks*. Ben is shown in full dress near Mount Rushmore in this photograph, probably from the 1950s. (Photograph courtesy of the Keystone Area Historical Society.)

Paha Ska (Orville Salway), an Oglala Sioux, was long a recognizable figure in Keystone and was often photographed with tourists, as in this shot from about 1990. Paha Ska owned a studio in Keystone where he sold his artwork. He was called "Good Will Ambassador for Keystone and South Dakota" for almost 50 years. Gov. Bill Janklow signed a proclamation designating May 24, 1997, as Paha Ska Day. Paha Ska passed away on November 10, 2005. (Photograph courtesy of the Keystone Historical Museum.)

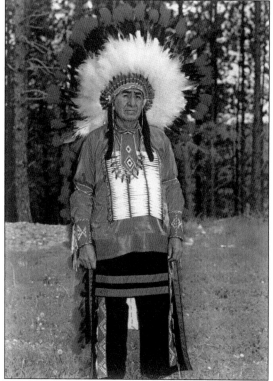

Charlie Big Cloud, an Oglala Sioux, also spent many years in Keystone, where he would wear traditional Oglala clothing and greet visitors. Big Cloud is shown in this c. 1962 photograph. (Photograph courtesy of the Keystone Historical Museum.)

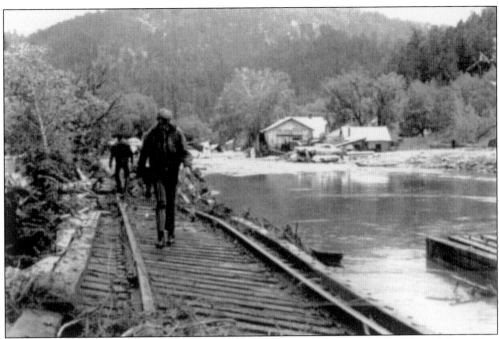

On June 9, 1972, a catastrophic flood devastated the central Black Hills and Rapid City. This photograph, in the aftermath of the flood, looks east down Grizzly Bear Creek. The railway bed shown was never re-opened for service. Twenty-two people, all tourists, lost their lives in the flood that swept through Keystone. (Photograph courtesy of the Keystone Historical Museum.)

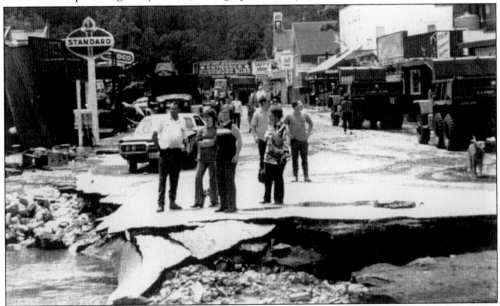

This photograph from the 1972 flood is directed south toward Winter Street. Oscar and Baldwin Sagdalen operated the Standard station intermittently. Today, the Ruby House Restaurant sits on the site. The Conoco station in the background was the original site of the Keystone Auto Camp but is now home to Keystone Souvenirs. (Photograph courtesy of the Keystone Historical Museum.)

During the life of Keystone, four major fires have swept through Main Street. Fires along Winter Street, too, have taken their toll. This c. 1976 photograph shows the Keystone House Restaurant on Winter Street, which fire consumed in late 1970s. (Photograph courtesy of the Keystone Historical Museum.)

This photograph from the late 1970s shows the Keystone House Restaurant torched by flames. The restaurant was located on the west side of Winter Street. It was rebuilt and is in operation today. (Photograph courtesy of the Keystone Historical Museum.)

This *c.* 1955 photograph shows "Wild Horse Harry," otherwise known as Harry Hardin, an old prospector who entertained tourists in Keystone. He walked the streets with his donkey, Sugar Babe, equipped with his gold pan and other mining tools. Although he was born 20 years after the Battle of the Little Bighorn, Hardin told tourists he was a "survivor of the Custer Massacre." (Photograph courtesy of Landstrom's Jewelry.)

This photograph shows Harry Hardin's grave site, located in Keystone's Mountain View Cemetery, which provides a fine view of Mount Rushmore. Hardin dressed as a prospector and would always be seen wearing an old hat with a horse-blanket pin to hold up the brim. (Photograph courtesy of Robert E. Hayes.)

The Rushmore Borglum Story, also called the Borglum Historical Center, is a museum devoted to the life and times of Gutzon Borglum and the history of Mount Rushmore. Many items of interest are on display at the center, including the sculpture shown in this recent photograph. In the sculpture, Borglum depicts his son, Lincoln (left), and himself. This sculpture is the only one he ever created depicting himself. (Photograph courtesy of Robert E. Hayes.)

This recent photograph shows "The Seated Lincoln," a permanent fixture at the Rushmore Borglum Story. During the Civil War, Abraham Lincoln was known to trade the White House for the grounds outside where he sat on a bench to think and gather courage. Teddy Roosevelt dedicated "The Seated Lincoln" at a ceremony on Memorial Day 1911, in Newark, New Jersey. (Photograph courtesy of Robert E. Hayes.)

This photograph shows the "Klondike Casey" pulling the 1880 train across the first trestle out of Keystone sometime before the 1972 flood. The trestle served as an underpass for automobiles. Battle Creek also ran beneath it. (Photograph courtesy of Robert E. Hayes.)

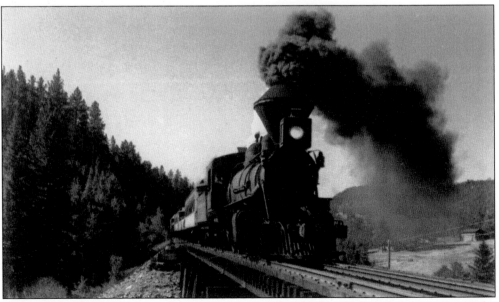

This recent photograph shows the 1880 train crossing a bridge along its historic route in the central Black Hills. (Photograph courtesy of the 1880 Train.)

The President Alpine Slide is only a few years old in Keystone. At the attraction, tourists ride to the top of the mountain in a chairlift. The riders can return to the parking lot on the chairlift or they can ride the water slide to the bottom. (Photograph courtesy of the Presidents Alpine Slide.)

Riders on the water slide speed through the pines at the President Alpine Slide. Paul and Stillman Hazeltine operated a sawmill at the base of the mountain in the 1920s. (Photograph courtesy of Robert E. Hayes.)

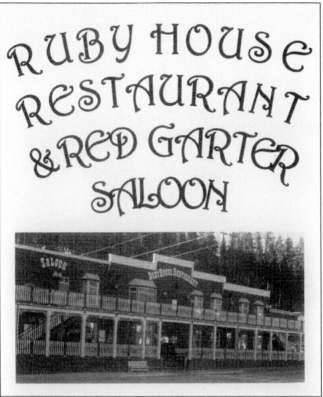

This image from a recent advertising brochure shows the Ruby House Restaurant and Red Garter Saloon located along Winter Street. (Image courtesy of the Ruby House Restaurant.)

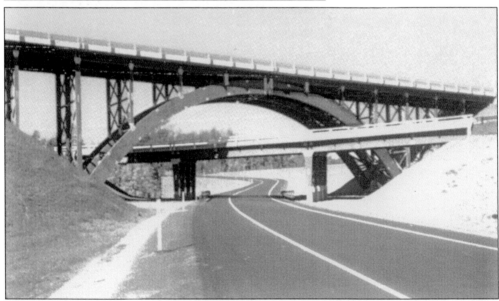

This recent photograph shows the Keystone wye, an intricately designed overpass/underpass located at the intersection of U.S. Highway 16 and 16A. U.S. Highway 16A begins at this location and winds through Keystone, directing the traveler toward Mount Rushmore approximately four miles away. U.S. Highway 16A continues over the scenic Iron Mountain drive and on to Custer State Park. (Photograph courtesy of Robert E. Hayes.)

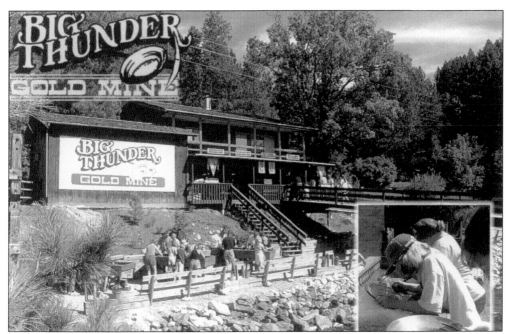

The Big Thunder Gold Mine in "Old Keystone" caters to those who want a mine tour or want to try gold panning. (Photograph courtesy of the Big Thunder Gold Mine.)

Visitors touring the Big Thunder Gold Mine will see old mining equipment, such as this ore car. The style of the car is a rocker dump car and it dumps on either side of the car. It appears to be sitting on a turntable. (Photograph courtesy of the Big Thunder Gold Mine.)

KEYSTONE FIRE – June 18, 2003
White House Resort

This photograph depicts another devastating fire in Keystone. The White House Resort and several other businesses burned to the ground on June 18, 2003. The area has been entirely rebuilt. (Photograph courtesy of Carolyn Clifford.)

This recent photograph shows the east side of Winter Street—or the Strip—during the annual Black Hills Sturgis Motorcycle Rally. The rally officially runs for seven days in early August; however, thousands of bikers come early and stay after the rally ends. The annual event draws in the neighborhood of 500,000 bikers each year. (Photograph courtesy of Robert E. Hayes.)

The National Presidents Wax Museum in Keystone depicts in wax all things presidential. Retired New York fireman Bob Beckwith poses in front of the waxen images of himself (center) and Pres. George W. Bush (left) at Ground Zero—the site of the September 11, 2001, terrorist attack in New York City. (Photograph courtesy of Robert E. Hayes.)

This recent image from an advertising brochure shows the restaurant and office at the Powder House Lodge. The grounds at the attraction sit on seven claims that Fred Cross, the first permanent resident of the Keystone vicinity, located in the late 19th century. (Image courtesy of the Powder House Lodge.)

Bruce and Margie Schlitz, shown recently standing near one of their helicopters, have operated the Rushmore Helicopter Tours in Keystone for 45 years. Their routine tours circle Mount Rushmore, providing their passengers with a bird's-eye view of the mountain and of Keystone. The tours they offer include flights near Crazy Horse Memorial and other locations in the Black Hills. (Photograph courtesy of Rushmore Helicopter Tours.)

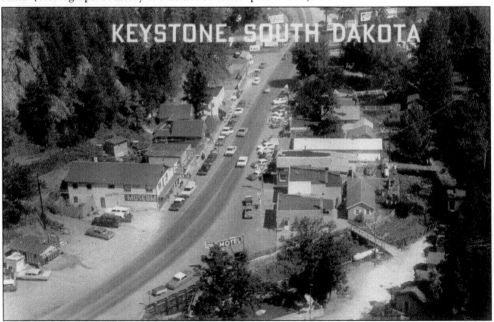

This recent image from a postcard shows Winter Street—or the Strip—along Highway 16A in Keystone. The Strip offers the nearest approach to Mount Rushmore, which rises approximately two miles away. (Photograph courtesy of Black Hills Souvenirs and Gifts.)

Joe Bruner, a Mount Rushmore carver, holds granite taken from the left eye of Thomas Jefferson during the carving years. Bruner was photographed for a newspaper article that ran along with this image in 1966. Bruner was one of Borglum's top carvers. He worked as a stone cutter in Bloomington, Indiana. (Photograph courtesy of Edith (Bruner) Nettleton.)

This group shot of former Mount Rushmore workers and family members was taken on July 2, 1989—the 50th anniversary of the Roosevelt dedication on Mount Rushmore. From left to right, they are (first row) Raymond Berg, Elsie Oaks (widow of Earl Oaks), Emmett "Ole" Oslund, Robert "Bob" Himebaugh, and Arthur Lyndoe Jr.; (second row) George Rumple, Bernice Maxwell (widow of Frank Maxwell), Edwald Hayes, and Raymond Kingsbury. All have since passed away. (Photograph courtesy of Robert E. Hayes.)

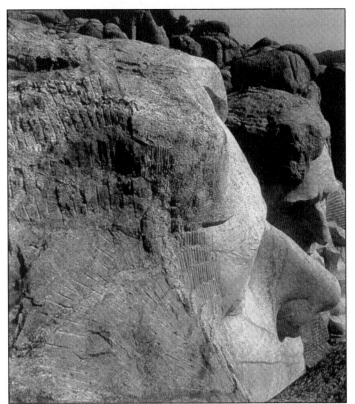

Thomas Jefferson appears in the foreground while Abraham Lincoln appears in the background of this c. 1960 photograph. During the carving years, visitors were allowed to climb to the top of the mountain and watch Borglum's men work. For 25¢ each, a guide would send tourists up the stairways on the mountain. The guide would ride the cable car up, meet the tourists at the top of the stairway, give them an educational tour, then send them down the steps while he rode back down in the cable car. (Photograph courtesy of the Keystone Historical Museum.)

This c. 1940 photograph of Theodore Roosevelt may have been shot from the cable car that ran up the mountain or from atop Lincoln's head. (Photograph courtesy of the Keystone Historical Museum.)

Every fall, a maintenance program is initiated for several weeks at Mount Rushmore. Cracks in the rock are filled to prevent erosion. Borglum's original recipe for a filling compound was a mixture of white lead, linseed oil, and granite dust. Today, cracks are filled with silicone cement. This photograph probably shows either Bob Crisman or Herb Conn hanging from the profile of Lincoln, around 1950. (Photograph courtesy of the Keystone Historical Museum.)

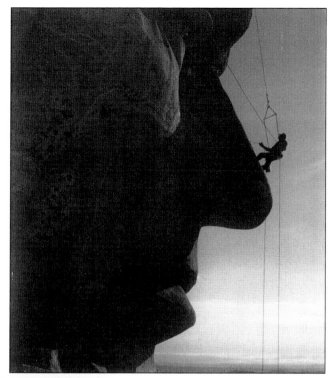

This *c.* 1960 photograph shows a portion of the 450,000 tons of granite blasted from the mountain. Note the drill-hole pattern on the broken rock. Holes were drilled close together, then packed with light charges. This process allowed the granite to be "gently" blasted away without fracturing the surface beneath.

Look to the past to find the future, for in the past—like gold buried deep in the distant mountains—lies the soul, and there is no future without the soul. (Photograph courtesy of Alice Ozmun.)